£7·60

Digital Macro Photography

Digital Macro Photography

Ross Hoddinott

photographers'
pip
institute press

Published in 2007 by
Photographers' Institute Press
an imprint of Guild of Master Craftsman Publications Ltd,
166 High Street, Lewes,
East Sussex, BN7 1XU

Reprinted 2008, 2010

First published in hardback in 2006

Text and photography © Ross Hoddinott 2006 except
where otherwise stated
© in the Work Photographers' Institute Press 2006

ISBN: 978-1-86108-530-6

A catalogue record for this book is available from the
British Library.

The right of Ross Hoddinott to be identified as the
author of this work has been asserted in accordance
with the Copyright, Designs and Patents Act 1988,
sections 77 and 78.

Associate Publisher: Jonathan Bailey
Managing Editor: Gerrie Purcell
Production Manager: Jim Bulley
Editor: James Beattie
Managing Art Editor: Gilda Pacitti
Designer: Rebecca Mothersole

Colour origination by Wyndeham Graphics
Printed and bound by Hing Yip Printing Co Ltd, China

Dedication I'd like to dedicate this title to my parents, Mike and Tricia, and to my wife, Fliss. I have much to thank my parents for, not least for passing on to me their passion for everything outdoors. As a kid, they nurtured and encouraged my love of wildlife. Also, after seeing how unhappy I was at school, they decided to educate me at home. Only now am I beginning to appreciate what a huge sacrifice to their lifestyle this must have been. However, not once did they complain or voice any regrets. Soon, I discovered photography, and, whilst others doubted I could make a living from taking pictures, my mum and dad's encouragement and support never wavered. Their belief in me is only matched by that of my beautiful wife Fliss. Thank you is just not enough, which is why this, my first book, is for you: my three best friends.

Acknowledgements Firstly, I'd like to thank Keith, Ailsa, Tracy and Elizabeth at *Outdoor Photography* magazine for giving me my first opportunity to write about photography, it encouraged me so much. Thanks also to Ben Hawkins for his ongoing help; Tom 'lad' Collier and James Roberts for letting me pick their brains on wildlife; and Canon, Matt at Mifsuds Photographic and Cynthia Fenton at Tripodhead for help with equipment. Thanks to Gerrie Purcell and the team at Photographers' Institute Press, for giving me this opportunity. Finally, huge thanks to James Beattie at Photographers' Institute Press. You don't know how much I've appreciated your help and relaxed, professional approach.

In memory of Jack Turnbull. Thank you for your enthusiasm, help and encouragement; it's greatly missed.

Contents

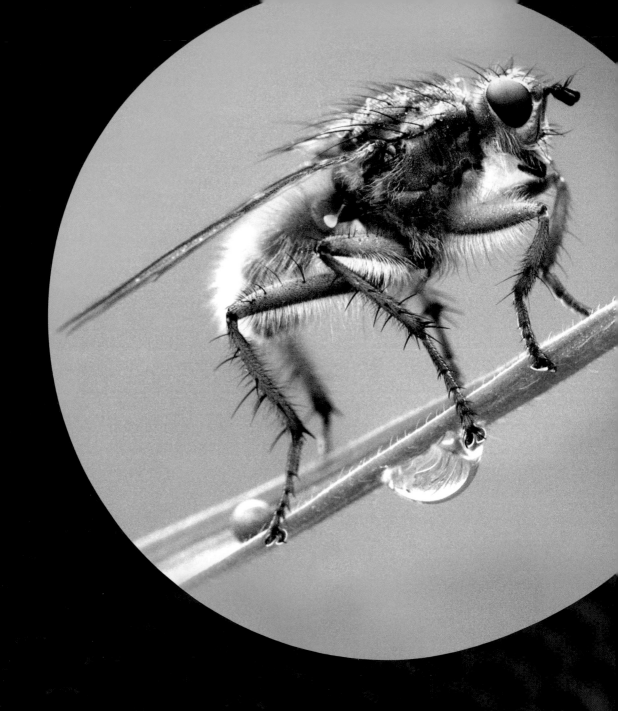

Digital cameras
and technology

Introducing digital macro photography

Whatever your level of experience, digital technology and terminology can prove more than a little confusing. Like it or not, digital photographers need to familiarize themselves with a whole new language. But don't panic; while it might appear complicated at first, it's not as daunting as you might imagine.

Before going further, it's worth clarifying a few terms. Firstly, the reproduction ratio is the size of the subject in relationship to the size it appears on the sensor (or film in a film body). In other words, if an object an inch wide (25mm) appears 1/4in wide (6mm) on the sensor, the reproduction ration is 1:4. If it appears the same size, then it has a life-size reproduction of 1:1. This can also be expressed as a magnification factor – a ratio of 5:1 equates to a subject which appears five times its size on the camera's image-sensor or is 5x life-size. A lens will have its maximum magnification listed among its features, and a macro lens will normally boast a 1x (life-size) maximum magnification. Note that the reproduction ratio and the maximum magnification refer to the size of the image on the sensor, not the size to which the image is subsequently enlarged on screen or when printed.

Close-ups can be divided into three categories: close-up, from 1/10th life-size to just below life-size; macro, from life-size to 10x life-size; and micro, above 10x life-size. Ratios from 1:4 to 1.1 are fine for most subjects, and the majority of the images in this book fall within this range. However, despite many of the pictures we take not being truly macro, most photographers still use the term to describe their close-ups. Although this might be technically incorrect, does it matter? After all, it's the quality that matters, not the precise reproduction ratio.

▲ (lifesize.tif)
A shot of a damselfly shown at life-size.

▲ (twicelifesize.tif)
The same shot shown at twice life-size.

▲ (fivelifesize.tif)
The same shot shown at 5x life-size.

Digital cameras

There are a wealth of digital cameras available, at a huge variety of prices and with a massive range of specifications. Choosing the right one is a question of understanding what is on offer, and what offers the best value for money for your photography.

Digital compacts

Compact cameras are an excellent introduction to the world of digital capture. They're small, lightweight and aimed primarily at amateur photographers. For a relatively small outlay you can buy a model boasting an impressive array of features, often including a 'macro' or 'close-up' facility.

Although many cameras boast higher resolutions, four megapixels is generally considered to be the minimum requirement and should be fine for printing up to A4 size. A typical compact will have a 3x to 5x optical zoom and the ability to focus closer than a film compact, so most are well suited to capturing static close-ups; however, more active subjects may hop or fly away before you can get close enough.

Compact users should bear in mind that what you see through your viewfinder isn't precisely what's being captured, as the viewfinder is offset to the lens. Although this is not generally noticeable, the effect is more obvious when shooting close-ups as this 'parallax' problem is exaggerated. However, on most compacts, you can avoid this by composing images via the live feedback on the camera's LCD monitor; in fact, many digital compacts no longer have a conventional viewfinder.

Although compact users will not enjoy the same level of control over their photography as a DSLR owner, the quality, size and weight of compacts make them very practical. They can easily be carried everywhere in your pocket, thus ensuring you never miss an opportunity.

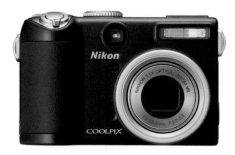

◀ (coolpixp5000.tif © Nikon)
High-quality digital compacts like the Nikon Coolpix P5000 are bursting with features. It offers a 10-megapixel resolution and a 3.5x optical zoom, as well as a macro function allowing it to focus as close as 1½in (4cm).

SLR-style digital compacts

If you're looking for a little more than a compact can offer, but your pocket won't quite stretch to a DSLR, then an SLR-style compact camera is a compromise. They borrow the ergonomic grip and style that are associated with an SLR, but do not benefit from the flexibility of interchangeable lenses. Instead, like a normal compact, they have a fixed zoom lens. Most are compatible with accessories like filters and converters, making them more versatile than a standard compact. In macro mode, many models can focus as close as 1in (2.5cm), making them appealing to close-up enthusiasts.

Photographers are also able to take greater creative control over the picture-taking process, by overriding the automatic settings and selecting shutter speeds and apertures manually. In addition to having all the features of a standard point-and-shoot compact, most SLR-style cameras also boast a higher-resolution sensor and can shoot in either raw or jpeg modes (see page 24).

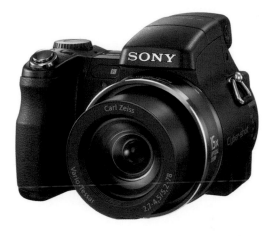

▲ (cyber-shotdsc-h9.tif © Sony)
SLR-style compacts, like the Sony Cyber-shot DSC-H9, are compact and portable yet still boast a high performance, which will appeal to both beginners and enthusiasts.

Many compacts boast vast zoom ranges of maybe 10x or even 20x. This might sound impressive at first, but it actually refers to the combination of digital and optical zoom. Digital zoom, in effect, enlarges the image, unlike optical zoom which magnifies the subject using the lens. Digital zoom causes image quality to deteriorate, and noise becomes more visible (see page 20). Avoid using digital zoom, instead rely on the optical zoom to produce the best results. So, when you're considering a compact camera, remember the optical zoom is more important than the digital zoom.

jargon busting: **Optical or digital zoom**

DSLRs (Digital Single Lens Reflex cameras)

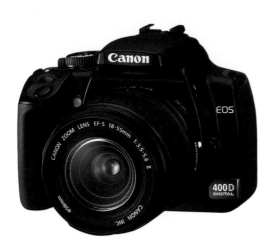

▲ (canon400d.tif © Canon)

Canon is a leading camera manufacturer. The EOS 400D / Digital Rebel XTi is an entry-level model with an impressive 10.1-megapixel resolution sensor, at an affordable price.

Film SLRs have long been preferred by photographers wishing to take creative control over their pictures; including many professionals. Now Digital Single Lens Reflex (DSLR) cameras, have taken up where their film brethren left off. They are designed with a lens mount; so they can be used with a system of interchangeable lenses, which makes them ideal if you already own a film SLR with lenses to fit. The only disadvantage is that the model you choose will often be dictated by the make of your existing gear, rather than by an objective judgement.

DSLRs' popularity is largely due to their incredible flexibility. For all their qualities, compacts are limited by their lens, whereas DSLR users can buy a variety of optics, and close-up photographers can expand the camera's capabilities further by adding accessories, like extension tubes, bellows and ring flashes.

Six megapixels is widely considered to be the minimum resolution for a DSLR. While you may find higher-resolution compacts at lower prices, a DSLR will normally provide you with better image quality and more versatility, so should definitely be considered if you are serious about your photography.

DSLRs have a variety of exposure modes, light-metering modes and autofocus modes, as well as a number of options to determine the technical parameters of the digital image itself. You can even alter the way the camera performs by customizing various functions and settings. Their all-round performance also tends to be better than that of compacts, with autofocusing being quicker and more accurate, and they also offer manual focus, which is great for close-ups.

One disadvantage of using a DSLR is the weight of carrying a camera body along with accompanying lenses. They can also be significantly heavier than a compact camera, but this is because they tend to be far sturdier. The benefits of a DSLR far outway the negatives, and if your budget will stretch as far as a DSLR, it will be money well spent.

When buying a camera identify a few suitable models and compare them to assess which is the best value. Try two or three models in a shop, and, once you have made a decision check that the price is competitive. Also consider used cameras; as long as a camera does the job, its age isn't really an issue.

Care and maintenance

A digital camera can be a big investment, and by looking after it well you can maximize its working life. The majority of camera maintenance is common sense: when they are not being used, keep your camera and lenses safe and dust-free in a suitable padded camera bag or holdall of some type. Cameras don't like being exposed to excessive cold or heat, so don't leave your kit in the car on a warm summer's day – not to mention the risk of theft. Avoid exposing equipment to moisture, but, if you can't, dry it soon after with a soft, clean cloth. It's best to use a blower brush to remove dirt from the lens and viewfinder.

DSLR users, in particular, need to care for their cameras. Whereas digital compacts are a sealed unit, the internal workings of an SLR are exposed to dust and dirt when a lens is changed. Over time, it's inevitable that the image sensor will get grubby. Even tiny particles of dust will create black specks on the resulting images, being especially obvious at narrow apertures. To view the extent of the dust on your camera's sensor, photograph a light, regular-coloured subject – a blue sky, for instance – using a small aperture of f/16 or f/22. Although images can be cleaned using the heal or clone tools in Photoshop (see page 159), this will become tedious and time-consuming if the sensor is allowed to get increasingly dirty. Ideally, have the sensor cleaned professionally; however, this can be costly and leave you without a camera for several days. Cleaning the sensor yourself is a delicate job and one which should be approached with care. To do this, lock the mirror in the up position to expose the sensor. Most models allow you to do this via the menu. Do not use cleaning fluid, a cloth or compressed air; instead try using a specially designed blower brush. Hold the camera upside down so the dust can fall out. This process will remove all but the most stubborn particles of dirt. Otherwise, buy a cleaning solution and swabs (available at most good camera shops) designed specifically for image sensors; and follow the instructions carefully.

Terminology and technology

Digital photography has inherited much from film photography; however, there are a number of new terms that you need to understand in order to get the most from your photographic equipment.

The sensor

At the hub of a digital camera is its sensor. This comprises millions of photodiodes and their associated circuity, which together are known as pixels. The most common sensors are Charge Coupled Device (CCD) and Complementary Metal Oxide Semiconductor (CMOS) sensors, and while each has different characteristics, most work in a similar way.

When a picture is taken, each photodiode creates an electrical signal in response to how much light it is exposed to. The majority of sensors are overlaid by a Bayer mosaic, which filters light into red, green and blue. Each individual diode reads the quantity of the light striking it and gives a reading for that particular colour. This information is converted into an electrical signal and transferred to the buffer, where the information from each pixel is combined with that from its neighbours to create an image which has full colour in every pixel. The information is then passed to the storage media.

The number of pixels used to capture a photograph is known as the resolution, and this is commonly expressed in megapixels (one million pixels). So, a camera, like the Canon EOS 350D / Digital Rebel XT, with a 3456 x 2304 pixel sensor, has an effective resolution of 7.96 megapixels – this is rounded up to 8 megapixels, which is the commonly given resolution.

The majority of sensors are 'cropped', which means they're smaller than a traditional 35mm film frame. This has an effect similar to multiplying the focal length of the lens attached, although by how much depends on the size of the sensor. With a digital SLR this cropping factor can be between 2x and 1x (full frame); for example, a 200mm lens used with a DSLR that has a 1.5x factor will have a similar field of view to a 300mm lens used on a 35mm or full-

◀ (sensor.tif © Nikon)
The Sony 6.1 megapixel CCD employed in the popular Nikon D70.

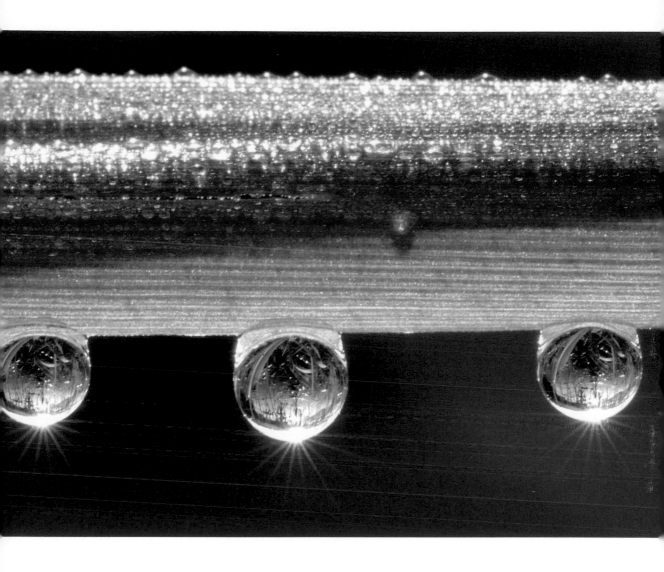

▲ (waterdroplets.tif)

Due to my camera's cropped sensor, the effective focal length of my 150mm telephoto macro lens is enhanced by 1.5x. This allows me to take frame-filling macro shots of tiny subjects, like these water droplets, precariously suspended from a single, backlit blade of grass.

Nikon D70 with 150mm lens, 1/13sec at f/20, ISO 200, tripod

frame SLR. This is a disadvantage for landscape photography, as wideangle lenses lose their characteristic effects; however, it can be beneficial for wildlife and macro photographers, as it allows a larger working distance or effectively increases the subject's size within the frame.

Cameras employing full-frame sensors – which maintain an equivalent focal length effect to 35mm film camera – are also available. They have higher resolutions, and usually larger individual pixels, which improves image quality; but they are only employed in professional-specification models with a price tag to match. Even if you can justify the outlay for a full-frame model, macro enthusiasts will still find a cropped-sensor camera handy.

Foveon sensors On conventional sensors each pixel captures a single colour, because of the Bayer filter overlaying the sensor. However, Foveon sensors boast three layers of photodetectors embedded in silicon crystal. Silicon can absorb different colours at varying depths, enabling each pixel to receive red, green and blue light. One advantage of this is that the digital image does not require processing to remove the 'coloured jaggies' that can be created by conventional sensors. There is some debate whether each stack of three photodiodes should be counted as a single pixel or individually. For instance, Sigma advertises their SD10 as a 10.2-megapixel camera, even though it produces a file of 3.4 million full-colour pixels.

Four Thirds system The Four Thirds system utilises a Bayer mosaic CCD that has an aspect ratio of 4:3 (it is squarer than a conventional frame). It was devised by Olympus and Kodak to free manufacturers from the onus of providing compatibility with traditional camera and lens formats, and the system has subsequently been supported by Panasonic and Sigma. The diameter of its lens mount is roughly twice as big as the image circle, allowing more light to strike the image-sensor from straight ahead, thus ensuring sharp detail and accurate colour even at the periphery of the frame. The small sensor effectively multiplies focal lengths by two, enabling manufacturers to produce more compact, lighter lenses. The Four Thirds system is providing a growing challenge to more conventional systems.

◀ (olympuse500.tif © Olympus)
One of the intentions of the Four Thirds system is to provide an open standard, allowing consumers to interchange bodies and lenses produced by different manufacturers.

ISO rating ISO stands for International Standards Organisation and is an indicator of the sensitivity of both film and digital sensors. However, one of the main advantages of a digital camera is that its ISO rating can be altered. This allows you to increase the ISO to make the sensor more sensitive to light, or decrease the ISO to make it less sensitive. More sensitivity is useful if you wish to photograph in low-light conditions or if you wish to use faster shutter speeds. The ISO can be easily adjusted, and, while the ratings available vary from camera to camera, a typical DSLR will offer a range of ISO 100–1600.

While high ISO settings are useful for low-light and fast-motion photography, they also suffer from increased noise (see page 20), so it's wise to employ the lowest ISO setting possible in a particular situation.

▼ (dungfly.tif)
To photograph this small dung fly, I needed to employ a high level of magnification. A minimum aperture f/11 was required to achieve enough depth of field to keep the fly acceptably sharp. At this aperture I required an ISO rating of 800 to allow a fast enough shutter speed to capture an image without blur.

Nikon D70 with 150mm lens, 1/80sec at f/11, ISO 800, tripod

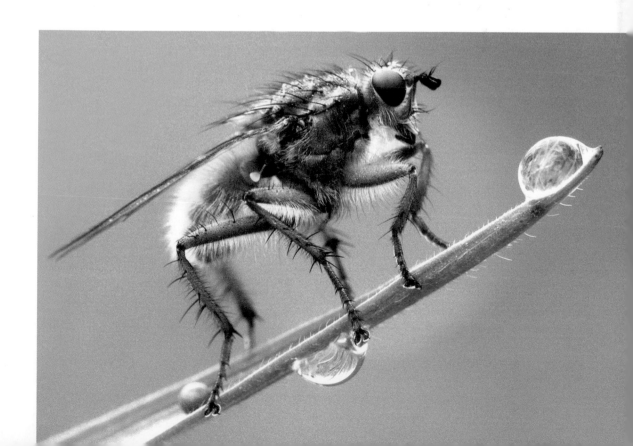

◀ (digicII.tif © Canon)
The DIGIC II buffer that processes the images captured by the Canon EOS 350D / Digital Rebel XT.

The processor

A digital camera has, like any computer, a processor. This internal memory carries out a number of functions, among which it applies image settings to the information that the sensor has captured. This includes applying the white balance and any processing that is built in to minimize digital problems (see page 20).

The internal memory also has the capacity to store a certain number of images before they are written to the storage media. This is known as the camera's buffer, and determines its burst rate – how many frames per second (fps) it can shoot – and its burst depth – how many images it can capture in a single burst. When the buffer is full the burst rate drops dramatically, as an image has to be written from the buffer to the card before another can be taken. Burst rates vary greatly from one camera to the next, but many DSLRs are capable of shooting around 3–4fps. Likewise the burst depth varies greatly from one model to the next and also depends on the type of file you are shooting. The number of images that can be captured varies from three or four to being limited only by the capacity of the memory card. The problem of filling the buffer is most likely to affect photographers who shoot long bursts to capture moving subjects; close-up snappers often shoot static subjects, so this is rarely an issue for macro photography.

White balance Every light source contains different amounts of red, blue and green. However, our eyes automatically correct colour casts – natural or artificial – so we perceive most light as white or neutral light and find different light types largely indistinguishable from one another. A digital sensor isn't so discerning, and the temperature of light – measured in degrees kelvin (K) – creates a colour cast if not correctly balanced. This balance is achieved via a camera's white balance (WB) function. Most cameras are programmed with a variety of WB presets, designed to handle most conditions; you simply need to choose the appropriate setting. There is also an auto WB feature, which estimates the colour temperature within a certain range, although this can be erratic. White balance can also be used to adjust the colour temperature of a picture for creative purposes. Some photographers prefer a warm look to their images, and achieve this by setting the WB to compensate for cooler lighting than actually exists: for example, cloudy or shade when you are actually shooting in daylight.

The WB is applied by the processor rather than the sensor. If you shoot a raw file (see page 24) then the information is attached but not written into the file. This allows you to adjust the value later on a computer. However, when using jpegs and tiff files, shooting parameters, including WB, are applied in-camera, making it crucial to set the correct WB. For this reason, auto WB should only be relied upon in simple lighting situations or when shooting raw files. Remember you can always review the image on the LCD monitor (see page 18).

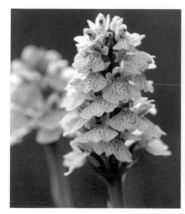 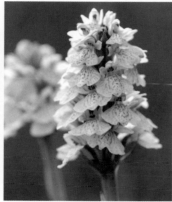 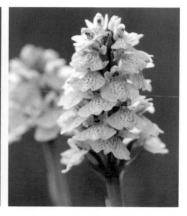

▲ (wbauto.tif, wbdaylight.tif & wbcloudly.tif)

These three shots illustrate the effects of different WB settings. I photographed this heath orchid late one evening in soft, low sunlight. The auto WB proved too cool, giving the image a slight blue cast. The daylight WB setting is more accurate, but I prefer the frame set at cloudy WB. In this instance, the added warmth produces a pleasing result. By shooting in raw, I was able to apply different WB settings on computer and decide which I preferred.

If you're shooting wildlife subjects they probably won't wait while you try to assess the colour temperature of the light. So, speed up the picture-taking process by using auto WB and shooting raw files. The WB can then be fine-tuned later on a computer.

pro tip

The LCD monitor

The rear LCD (liquid crystal display) monitor allows you to access menus or review and edit images. The advantages of this are that you can check composition, exposure and sharpness, and, if they are not satisfactory, adjust your settings and reshoot. The monitor also allows you to delete poor images, freeing up storage space. However, unless you've made an obvious error, it is better to check on a computer before deleting images. Using the LCD monitor also consumes power, so carry a spare battery or turn off image replay when it is not required.

Histograms A histogram represents an image's tonal range, and many digital cameras allow you to view one in playback mode. They are great for assessing exposure: the horizontal axis represents a range from pure black (far left) to pure white (far right), while the vertical axis shows how many pixels have a particular value. Although it is hard to generalize, a histogram with a large number of pixels at either edge indicates poor exposure with either lost shadow or highlight detail. Digital images are very versatile, but not all errors can be corrected on computer, and lost detail can't be salvaged. Although dependent on the scene, a good

histogram should show a range of tones, with few pure black or white pixels. When assessing a histogram, bear in mind the brightness of the subject itself. Histograms come in a variety of shapes, but a general rule is to ensure the majority of pixels are to the left of the mid-point. Digital sensors are more likely to lose highlight detail, and slightly underexposed images can be quickly lightened later on a computer.

Highlight and shadow alerts Many digital cameras have a 'highlights' function, which indicates areas that are pure white, normally by making them flash when the image is reviewed; some cameras also alert you to areas of pure black by making them flash. Like the histogram these alerts enable you to make adjustments to minimize lost detail.

pro tip

Before deleting images via your camera's LCD monitor, use the image-protection button ⊙ⁿ to protect your best shots.

Regularly downloading images from your camera will ultimately damage its delicate components. Instead, use a hardware card reader, which is relatively cheap, and connects to your computer via a USB or Firewire cable.

Storage media

When an image is captured the data is passed from the sensor to the buffer and on to some form of storage media. There are several types and several factors you should consider.

Card type CompactFlash (CF) cards are physically one of the largest. They're used in many DSLRs and are available in types I and II, with type II cards offering greater capacities. Type II compatible cameras will accept type I cards, but not vice versa. Microdrives are compatible with CF slots, but are less reliable than CF cards. Secure Digital (SD) cards are smaller than CF cards, but can still boast large capacities, and are increasingly popular for smaller cameras. They also have a write-protection switch, which can prove a welcome security feature. Other card types exist, such as Multi Media Card (MMC) and Smart Media (SM) as well as Fuji and Olympus's xD card and Sony's Memory Stick (MS). Although they vary in size and design, memory cards essentially do the same job; the type you require depends on your camera.

Capacity and speed It is worth choosing a fast card, but most modern ones can transfer data faster than the camera can, so it is rarely an issue. Capacity is also important, as high-resolution cameras produce big files. I use several 1 gigabyte (GB) and 2GB cards, allowing me to shoot without changing cards for a while, but not risk too many images in one place.

Formatting cards Once images have been downloaded, you should format the card to wipe the memory and guard against corruption. Protected images are also destroyed, so be sure that everything has been transferred first.

▶ (compactflash.tif © Integral Memory)
Large-capacity cards risk losing hundreds of images if one gets lost or corrupted. Instead, it's best to use a number of mid-range cards to spread the risk.

Digital problems

While digital photography has many benefits, there are also a number of problems that arise in digital images that were not present in film photographs. The major issues are explained below.

Aliasing

Digital images consist of millions of tiny pixels. Due to the shape of pixels, diagonal and curved lines can appear stepped or jagged as the corners of individual pixels become visible. This is called 'aliasing', but is also informally known as 'jaggies'. Many cameras have an anti-alias or low-pass filter fitted in front of the sensor, which reduces aliasing by softening the image, before it is resharpened by the processor. This is one reason why digital images sometimes still need a little more sharpening when processed on computer. The majority of digital cameras are designed with anti-aliasing technology, where the pixels along and around edges are averaged out. This gives diagonal and curved lines a smoother appearance. The risk of aliasing is enhanced on cameras with smaller image-sensors and lower resolutions.

Noise

Unrelated, brightly coloured pixels appearing randomly in digital images are known as noise and are especially visible in shadows. The effect they have is similar to – although often less pleasant than – the grainy appearance of photographs taken using fast (high ISO) film.

As discussed earlier a sensor is made up of a number of photodiodes. Each creates an electrical signal, which is then processed into a digital image. Interference between the diodes causes the appearance of noise in the image. Set at a low sensitivity, such as ISO 200 or lower, the level of noise is hardly noticeable; however, when sensitivity is increased the electrical interference is progressively amplified, resulting in a loss of quality. To minimize this, use the lowest ISO practical in any given situation.

Noise is also more obvious on pictures taken with shutter speeds of one second or more, as it can build up while the sensor is active. Some cameras have a noise-reduction (NR) option – which can be accessed via the camera's menu – that takes a dark frame and subtracts this background noise from the final image. Special noise-reducing software is also available for processing the effects out on computer.

▼ (iso200.tif & iso1600.tif)
I photographed these pine needles in close-up using my DSLR's lowest and highest ISO settings. They look identical at first glance, but when displayed at 100% as shown below the level of noise in the bottom image clearly affects image quality.

Moiré

The word 'moiré' is derived from the French word for mohair and is defined as 'having a wavelike pattern'. Its appearance in digital images is the result of interference between a regular pattern, found within the image, and the pixel grid. It occurs when the conflicting patterns clash, and results in wavy lines and false colours. The anti-alias (or low-pass) filter fitted in front of the sensor in many cameras is designed to reduce moiré in the same way as it reduces aliasing. Moiré is less of a problem with sensors which are able to detect the full colour range, like Foveon chips, and also cameras with high resolutions.

▼ (feather.tif)
Although most of the effects have been processed out, the effects of the wavy moiré pattern are still visible in this feather close-up.

Nikon D70 with 150mm lens, 1/2sec at f/22, ISO 200, tripod

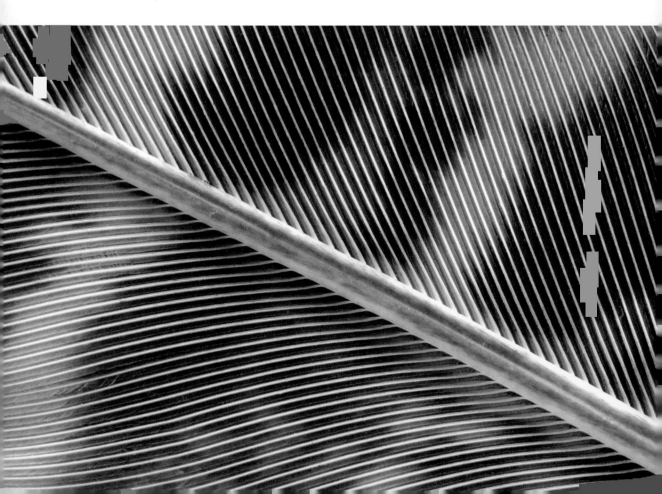

▲ ▶ (hogweed01.tif & enlargement)
By enlarging this shot of a frost-covered hogweed it is possible to
see the effects of chromatic aberration, with obvious colour
fringing.

Chromatic aberration

Chromatic aberration, or colour fringing, results when a lens is unable to focus the red, green
and blue wavelengths of light at a single point; it is a problem that afflicts all lenses to a certain
extent. It often appears as a red–green fringing, especially around contrasty edges, but is
normally only noticeable when an image is magnified. It's not unique to digital images – our
eyes suffer from chromatic aberration, and it also occurs on film – but digital cameras can
enhance its effect, because of their discrete pixel grid. Chromatic aberration can be reduced
by using high-quality lenses with an achromatic doublet or achromat element, or alternatively
by shooting raw images and converting them using the Adobe Raw Photoshop plug-in.

File types

Digital cameras allow you to record images in a number of file types. The types you choose should be determined by what you wish to use your image for once you have downloaded it.

Raw files

Raw files are essentially undeveloped digital data. They do not normally undergo any compression, and they are not processed, but the shooting parameters are attached so they can still be altered later. Each manufacturer employs a different raw format. Once the image is downloaded onto a computer, it should be processed either via the image software supplied with the camera or a program like Photoshop. Before processing is applied, the image may appear soft and dull. The shooting parameters, like white balance, tone and sharpness, can now be finely adjusted to achieve the desired end result. Different settings can be applied to the same raw file to produce slightly differing results. Admittedly, this type of processing can be a time-consuming business, but the final image will benefit from this fine-tuning. Some people still interpret any form of post processing as cheating. However, the principles of enhancing a raw file vary little from the tricks, like dodging and burning, traditionally used in the darkroom. Other than the processing time involved, the one disadvantage of shooting in raw is the room a developed file consumes. A typical raw image, taken using a 6-megapixel DSLR, is around 5MB. Once it's been processed and saved as a lossless tiff file, it will be nearer to 18MB in size, while cameras with larger resolutions will produce even bigger files. Be prepared for raw files to consume large chunks of memory on both storage media and your computer's hard drive.

◀ (convertingraw.tif)
Converting a raw file is made simple by using the software supplied with your camera. Alternatively, Adobe offers its Adobe Raw plug-in for Photoshop. Once you've made any necessary adjustments using the editing facility, you can either save images as jpegs or lossless tiffs. Converting a raw file enables you to retain a great deal of control over your images, and you can make adjustments that would not be possible with other files.

Jpeg files

A jpeg (named after the Joint Photographic Experts Group, which developed the format) is a compressed file, which is relatively small; therefore more will fit on your camera's memory card or your computer's hard drive. The shooting parameters, pre-selected to take the picture, are applied in-camera. So, after the file is transferred from the camera's buffer to the storage media, it's already the finished article; ready to print or use immediately once downloaded. This makes jpegs ideal for when a photographer needs to produce the end result with the minimum of fuss. Your camera should allow you to take jpegs in different quality settings; typically, fine, normal or basic. The basic and normal settings are ideal if you simply want decent snaps or low-resolution images to send via email to friends and family. However, in any other situation, you should shoot in jpeg-fine, set to its largest resolution. This will produce high-quality digital images. Compare two A4 prints, one made from a jpeg-fine file and the other from a processed raw image, and I defy even the most discerning eye to tell the two apart. However, the major drawback of shooting in jpeg is its lack of flexibility. As the shooting parameters have already been applied, snappers are unable to do a large amount of tweaking afterwards. So, if you do make a technical error, you're less likely to be able to salvage the photo than if you made the same mistake whilst shooting in raw. Nevertheless, being a compressed file, jpegs are smaller in size, making them easier to archive; but, being a lossy file type, each time you resave a jpeg you lose some of the original image data.

Tiff files

In addition to raw and jpeg files, some DSLR cameras are capable of capturing photographs as tiffs. Tiffs are 'lossless' files, so many photographers save and store their digital images as tiffs once the original raw file has been processed. However, shooting your images as tiffs has its disadvantages. Essentially, shooting in tiff is similar to shooting in jpeg, in the sense that the file is fully developed. It cannot be tweaked with the same impunity as a raw file, as the shooting parameters have already been applied. However, unlike jpegs, file sizes are big and will quickly fill memory cards and can slow the camera's burst rate. In all honesty, shooting tiffs is far less practical than taking pictures in jpeg format and far less flexible than taking them in raw format. However, once you have opened your raw or jpeg files on computer, a tiff is often the most appropriate format in which to store your files.

System requirements

Digital snappers should consider the computer to be a type of digital darkroom. Most households are already home to one, so for the majority of digital photographers there shouldn't be the cost of a new system. However, with digital cameras boasting ever-higher resolutions, file sizes are becoming larger. As a result, more memory is required to process and store them. Here are a few guidelines for upgrading or replacing your existing system.

Computers

A computer's processing power and storage capacity are key. If you work with large files you will need either an Intel Pentium or AMD Athlon processor of at least 2Ghz, along with a minimum of 256MB of Random Access Memory (RAM), as Adobe Photoshop – the industry's most popular image software – requires RAM of up to five times the size of the photo being edited. You will also want a large hard drive to store your images; even a 6-megapixel camera produces raw files that convert to 18MB tiffs, so a good rule is to own a computer with more free space and memory than you presently require.

DVD burners DVD drives and burners are increasingly useful because of the extra capacity a DVD offers. A CD accommodates about 700MB – roughly 40 high-res (18MB) tiffs. While, a blank DVD has a 4.7GB capacity and can host over 200 high-res tiffs. This makes DVDs a cost-effective way to back up images. However, storing so many images on a single disk is riskier, so it's best to archive images in this way in addition to using an external storage device. Of course, you can still burn CDs when you only need to write a small amount of data.

Laptops These are increasingly popular, and their weight and size make them convenient for photographers on the move, presuming that there is regular access to electricity. They can also be utilized as a portable storage device, although their size and fragility often make them impractical in the field. Professional photographers regularly travel with a laptop computer; downloading, processing and editing images to free up memory cards. A new laptop has the processing speed and RAM to run large graphics, as well as the capacity to store them, while a CD or DVD writer can be used to burn disks as a back-up. However, compared to a good desktop monitor, the glare – typical from a notebook's screen – can make it hard to evaluate an image's colour and contrast.

External hard drives By storing your images only on your computer's hard drive you risk losing all your shots should there be a major problem, for instance a virus or a fire. Digital images should be regularly archived, either by burning to CD/DVD or using an external hard drive or doing both. External hard drives are available in large capacities at relatively low prices. They connect to your computer either via a USB or Firewire port, and files can be

quickly copied onto the portable device, which can be stored in a separate place to your computer for added security. I use two high-capacity external hard drives and back up my raw and processed images at least once a week.

Portable storage devices A portable storage device (PSD) is a palm-sized external hard drive, capable of storing and displaying images. You can manage and edit images via the small monitor. Being small and lightweight, they easily slip into a camera bag, and are better suited to this type of storage than a laptop. Full cards can be quickly transferred in the field, allowing them to be reused when required. Capacities vary from one model to the next, but they are capable of holding a large number of files. Images can later be transferred to your workstation or stored as an extra form of back-up. The battery life should be a major consideration when you buy a PSD; the longer the better.

▶ (epsonp2000.tif © Epson)
PSDs, like the 40GB Epson P-2000, have large capacities and quick download times. The P-2000's impressive 3.8in LCD monitor makes viewing images easy.

Printers

The latest printers are capable of bitingly sharp results. Several types are available, but the most popular is the inkjet. Inkjet prints are created by thousands of tiny ink dots, laid down to simulate a continuous tone. Many inkjets boast a high print resolution. This shouldn't be confused with image resolution: while image resolution is measured in pixels per inch or ppi (the industry standard is 300ppi), print resolution is indicated by two values; for instance, the Epson Stylus Photo R1800 boasts 5760x1440 optimized dpi. The smaller number refers to the number of dots of ink per inch which it can print; the larger figure is the number of lines it can print along its length. Obviously the more dots per inch a printer is capable of laying down the better the print quality will be; 1440dpi gives true photo quality.

You can buy desktop printers capable of producing A4, A3 or even A2 prints. However, unless you intend to exhibit your work, an A4 printer should be fine for most purposes. Budget printers only use two cartridges: one black and one colour, which is a nuisance as, even if you have only consumed one colour, you will have to replace the whole cartridge. More advanced printers employ six or more individual cartridges, which is more economical and produces higher-quality results.

Lenses and close-up accessories

Lenses for digital SLRs

The main advantage of a DSLR system is that you are able to switch lenses at will. The range of lenses available will depend on the system of which your camera is a part, but they can all be categorized in the following way.

Wideangle lenses

Wideangle lenses are rarely associated with macro work, but they shouldn't be overlooked. Their short focal length is most suited to shooting sweeping vistas, which is why they're favoured by scenic photographers. Because many DSLRs employ a cropped sensor, they diminish the characteristic view offered by a wideangle lens.

Although wideangle lenses cannot magnify subjects sufficiently without the aid of an added close-up accessory, macro enthusiasts will still find them useful. Firstly, they're designed with a short minimum focusing distance; some wideangles can focus on a subject which is just 4in (10cm) away. This can be a handy and effective tool to create fresh and original close-ups, as focusing close to a subject using a wideangle lens can distort perspective. In my view, this is an effect best used for photographing flowers. For instance, by moving close and selecting a low angle, you can emphasize the height of a plant, showing it from a totally different perspective. Wideangle lenses are also useful for showing a subject within its environment. For instance, you might discover some fungi which, using a wideangle lens and small aperture (see page 52), you can photograph in close-up whilst still showing the woodland environment beyond.

The minimum focusing distance of a lens is the distance between the closest point at which the lens is able to focus and the sensor plane on which the image is focused.

jargon busting: Minimum focusing distance

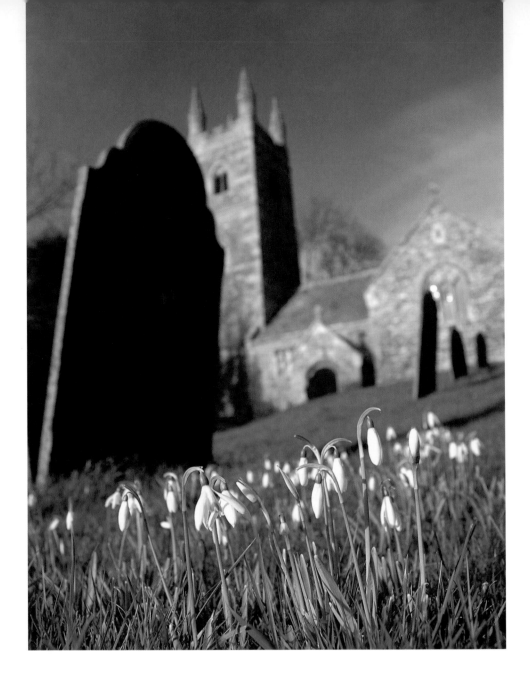

▲ (snowdrops.tif)

When I noticed these snowdrops in a graveyard, I decided to
show them within the context of their surroundings. Positioning
a wideangle lens very close to the base of the flowers, enabled
me to include the church and gravestones towering above them
in the frame.

Nikon D70 with 18mm lens, 1/640sec at f/5.6, ISO 200, beanbag

Standard lenses

Not long ago, practically every new SLR was sold with a standard 50mm lens, a focal length that offered a perspective similar to our own eyesight. However, short zooms have now superseded prime 50mm lenses, and the majority of DSLRs are sold with either an 18–70mm or 18–55mm zoom. The 'standard' focal length on most cropped-sensor DSLRs is about 35mm, as this offers the most natural perspective for the format; however, for full-frame sensors the standard is still 50mm. As zoom lenses advance, so traditional standard lenses are becoming a thing of the past. However, regardless of whether you have a standard prime lens or a zoom that includes a standard focal length, either one can be useful for taking 'straight' close-ups with no distortion of perspective.

Prime standard lenses are optically superior to the budget zooms that have replaced them. They are also an ideal lens to reverse or combine with extension tubes.

▼ (seaurchins.tif)
Sea urchins being sold by a fisherman formed an interesting and colourful pattern. I used a standard zoom to fill the frame.

Nikon D70 with 18–70mm lens, 1/20sec at f/20, ISO 200, handheld

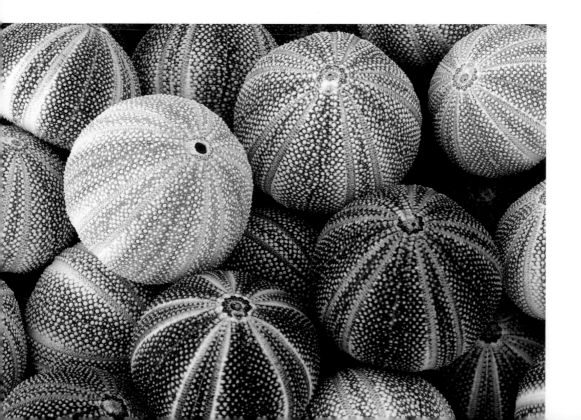

Telephoto lenses

Telephoto lenses are those that have a longer focal length than standard lenses. Both fixed focal length telephotos and telezooms are widely available in focal lengths up to 300mm; beyond which they start to become increasingly expensive.

One of their most appealing features is that they can be used from further away than a shorter lens, flattening perspective by bringing foreground and background together. They can also, when combined with wide apertures, be used to isolate a subject against a blurred backdrop, a pleasing effect that is tricky to achieve with shorter focal lengths.

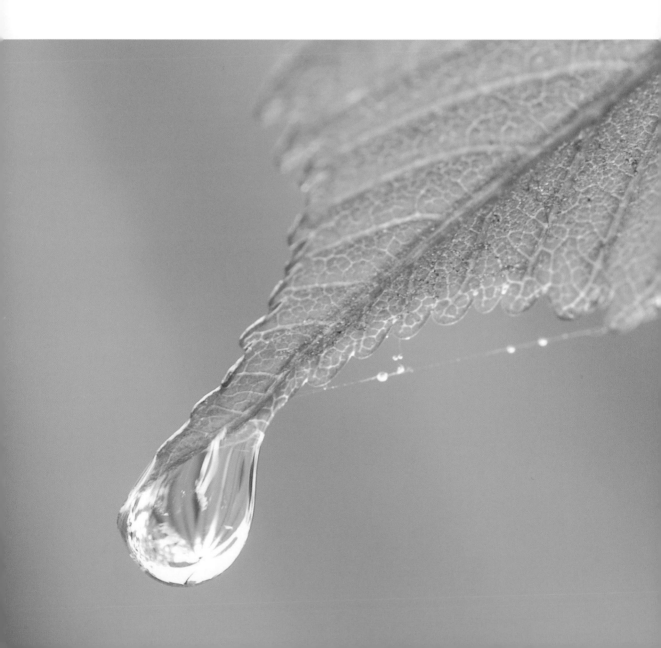

Photographers taking close-ups from further away will find the range of a telephoto useful. Zooms are a useful compositional tool, as they allow photographers to adjust framing whilst remaining in the same position. On the flipside, their minimum focusing distance can prove restrictive. Due to their complex internal workings, many telephoto and telezoom lenses are unable to focus closer than 3–6ft (1–2m). This working distance may be adequate for larger subjects, but not to take frame-filling shots of smaller objects. Some modern telephotos have a macro facility, although few of these reach a reproduction ratio of 1:1; for example, Sigma's 70–300mm APO zoom offers a half life-size (1:2) reproduction ratio at the 300mm end of its range. Other lenses can be used with some form of extension to reduce the working distance and to increase magnification. Telephoto lenses are longer and heavier than standard lenses, so some form of camera support is vital to achieve sharp, shake-free digital images.

◀ (leafdroplet.tif)
Long focal lengths are ideal for isolating a subject. I used a 400mm lens to photograph this water droplet hanging from a chestnut leaf.

Nikon D70 with 400mm lens, 1/5sec at f/11, ISO 200, tripod

APO is an abbreviation of apochromatic. APO lenses employ special low-dispersion glass to reduce chromatic aberration. Optics that are not corrected have a tendency to focus short (blue) wavelengths of light in front of medium (green) ones, with long (red) wavelengths focused behind. An APO construction will help bring all the wavelengths of the visible spectrum into focus at the same point. This corrects chromatic aberration, normally by using a number of elements made of different dispersion materials; however, chromatic aberration will still be present to a certain extent.

jargon busting: Apochromatic

Macro lenses

Macro lenses are designed specifically for close-up work, and can focus nearer than the equivalent conventional lens. Their optics are highly corrected to give the best results at close range, although they are also useful for general work. At their minimum focusing distance, most produce a 1:1 (life-size) reproduction, while some can create images up to five times life-size. They are the preferred choice of professional close-up photographers, myself included.

Macro lenses are available in a range of focal lengths. The shorter versions are compact, light and can be comfortably handheld. At their maximum magnification (minimum focusing distance) the front element will be very close to the subject. This isn't necessarily a problem with static subjects, but can be when shooting flighty insects; an approach this near is likely to frighten them away. Also, with the camera positioned this close to the subject, problems with natural lighting may arise. However, they are an ideal focal length for working in a studio.

Macro lenses upwards of 100mm are regarded as telephoto-macros. They make it easier to isolate subjects from their surroundings by creating an attractive background blur at wide apertures, and their increased working distance makes it possible to photograph subjects from further away. However, they can be heavy and awkward to handhold. For serious close-up photographers, a macro lens is a great tool, although some are extremely expensive.

▶ (darkbushcricket.tif)
It took me several minutes to position my camera so the cricket filled the frame. I moved slowly, to avoid frightening it away. I needed a high level of magnification, and a macro lens proved the best option, being relatively lightweight and easy to manoeuvre.

Nikon D70 with 150mm lens, 1/400sec at f/4.5, ISO 200, tripod

pro tip

While modern autofocus is fast, quiet and accurate, close-up photographers are often better off focusing manually. This gives you greater control over the point of focus and allows you to employ techniques such as hyperfocal focusing (see page 64).

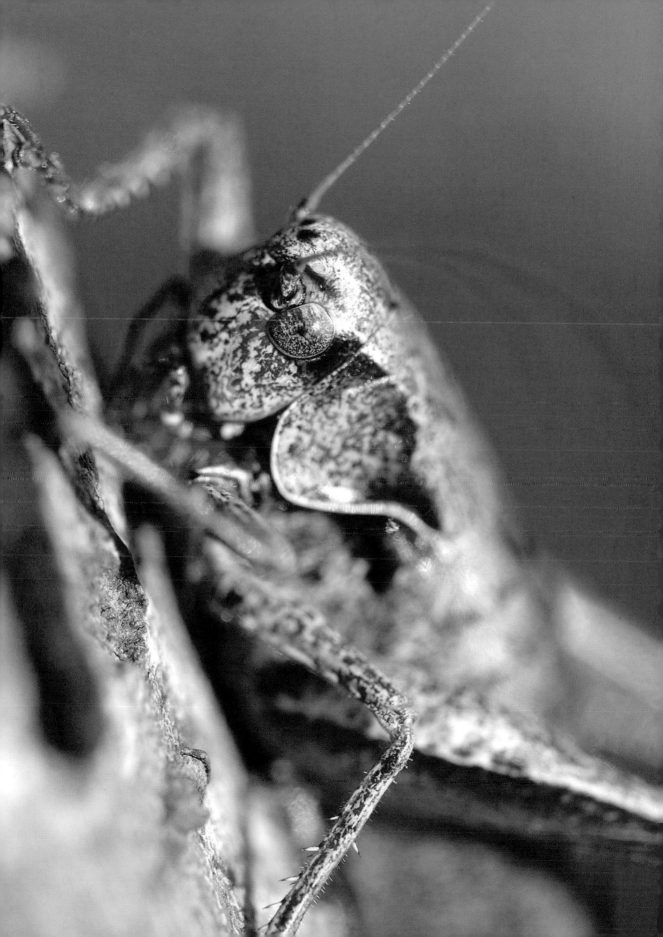

Teleconverters

Strictly speaking, teleconverters are optical components, not lenses. They're generally made in 2x and 1.4x strengths and are placed between camera and lens to magnify the focal length by that amount. This makes them handy for any photographer, as they're a light, compact and relatively cheap way to expand your kit's flexibility. To macro snappers their biggest asset is their ability to increase a lens's magnification without altering its minimum focusing distance.

Teleconverters are useful in many situations: the increased focal length allows you to shoot timid subjects from further away, or increase the maximum magnification when shooting tiny subjects like flies and grasshoppers. It's this versatility that makes teleconverters appealing, and is the reason I keep one in my camera bag. However, they do cause a loss of light – attaching a 1.4x converter to your camera will result in a one-stop loss; using a 2x converter will cause a two-stop loss. Automatic metering will accommodate this, but shutter speeds will be slower for a given ISO, so you should use a tripod. You might also notice a slight loss in image quality. Some lenses are incompatible with teleconverters, so check before you buy.

▼ (emperordragonfly.tif)
While watching this female dragonfly lay her eggs, I was only able to achieve a frame-filling result by using my 100–300mm telezoom combined with a 1.4x teleconverter.

Nikon D70 with 100–300mm lens and 1.4x teleconverter, 1/200sec at f/5.6, ISO 200, using elbows for support

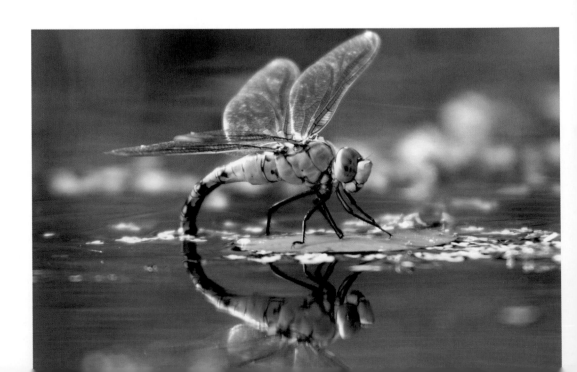

Camera supports

When using large magnifications, camera shake becomes increasingly visible so a camera support of some sort is a vital addition to your macro set-up. Preferably you should have more than one support so that you can choose the ideal option for different situations.

Tripods

The most stable form of camera support is the tripod; however, it is also the least convenient. A tripod not only improves stability, it also assists with precise composition and focusing.

When buying a tripod, you must also consider its design and flexibility. As a macro enthusiast, you will want a tripod which can be adjusted into almost any position. Benbo is renowned for producing tripods able to do this. They might be fiddly to position, seemingly having a mind of their own, but they are perfectly suited to the demands of outdoor macro photography. Tripods, which have legs that can be splayed almost flat to the ground, and which also have a reversible or removable centre column that can be placed horizontally, are well suited to close-ups. Try to avoid buying cheap, lightweight models, as their usefulness will be limited, regardless of whether you're using it in a studio or out in the field. Instead, buy a good, sturdy model; believe me, it's worth investing the extra cash. Unfortunately, sturdy can also equate to heavy. This is unless you can afford to purchase a carbon-fibre support, like the Explorer range by Gitzo, which can boast good stability despite being relatively light. Carrying a bulky tripod may not be much fun, but the resulting images will make it worthwhile.

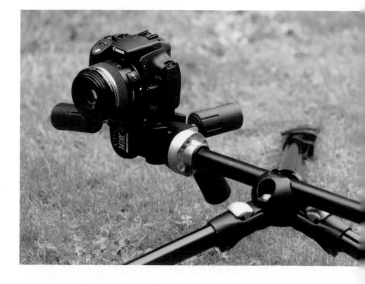

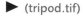 (tripod.tif)
The style and design of the tripod you buy is very significant. Macro photographers will find a support with a centre column that can be removed and positioned horizontally very useful.

Avoid raising a tripod's centre column unless necessary; this compromises its stability, especially if it's breezy. If your tripod has a hook from which to hang a weight, like your camera bag, use it to maximize stability.

Tripod heads Once you've decided on the design, weight and type of legs that suit your requirements, you need to match them with a suitable tripod head. Although some entry-level tripods are produced in a single piece, the majority are in two parts, the legs being compatible with a variety of different heads; it's best to match one made by the same company as the legs. Although there might seem to be a huge variety of complex designs, most are simply a variation of either the traditional pan-and-tilt or the very popular ball-and-socket head. A ball-and-socket head allows you to rotate the camera around a sphere and lock it into the position of your choosing. A pan-and-tilt design offers three separate axes of movement: left–right tilt, forward–back tilt and horizontal panning. Personally I prefer pan-and-tilt heads for the precision with which you can adjust composition. Try both types before you buy, as the style you choose should be based on your own personal preference. A tripod head boasting a quick-release plate is a good investment. The plate secures to the camera via its screw thread and snaps on and off the tripod head, allowing photographers to attach and detach their cameras easily.

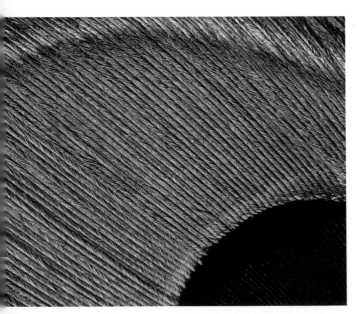

◄ (peacockfeather.tif)
At this magnification the smallest movement is exaggerated and a tripod is an essential aid. A pan-and-tilt head made it quick and easy for me to make fine compositional adjustments to this close-up of a peacock feather.

Nikon D70 with 150mm lens, 1/2sec at f/22, ISO 200, tripod

Monopods

A monopod is a simple camera support with a single leg. You attach the camera either via a head or directly to a screw thread. Once adjusted to the height required, you're ready to begin taking pictures without any of the fuss associated with positioning a tripod. Although a sensible compromise in situations where a tripod is impractical, a monopod cannot offer the same stability. However, using one is still preferable to shooting handheld, so they're worth considering as a lightweight alternative. They can also be easily strapped to the side of a camera backpack. Sports photographers regularly rely on monopods, as they are easy to handle and manoeuvre. However, close-up snappers will find them of limited use, though they can be handy when shooting flighty insects like butterflies, where the added support can help minimize camera shake while remaining flexible.

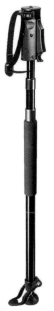

◀ (monopod.tif © Manfrotto)
Although close-up photographers will often rely on a tripod, there will be situations when a monopod will prove the only practical form of camera support.

Beanbags

Beanbags, designed specifically for photography, are a surprisingly effective form of support. Rested on a stable surface like a wall, car roof or the ground, a beanbag gives good, overall stability; the filling simply shapes to the camera or lens, and they're ideally suited to wildlife photographers using long, heavy lenses. Macro snappers may find them less practical; however, in situations where you wish to take pictures at ground level, they can prove the easiest and most effective solution. I find them useful when I'm shooting wild flowers as, although some tripods can be placed very near to the ground, they're tricky and time-consuming to position accurately. With a beanbag, you can begin taking pictures almost immediately.

▶ (beanbag.tif)
Beanbags offer great support for your camera and lens set-up when shooting low-level macro subjects, such as amphibians and wild flowers.

Close-up accessories

As macro and close-up photography is one of the most specialized and popular forms of photography there are a host of accessories to help you get the best from your subjects.

Supplementary close-up lenses

It's easy to assume that, to take great close-ups, you require extremely pricey lenses designed specifically for macro work. For those of you reading this who are new to photography or have a limited budget, you'll be relieved to learn that this just isn't true. I began taking pictures using a standard 50mm lens combined with a +3 dioptre supplementary close-up lens. Often mistaken for a filter, this is an inexpensive element that screws onto the front of your lens and acts like a magnifying glass. They're available in varying strengths and filter diameters, and are

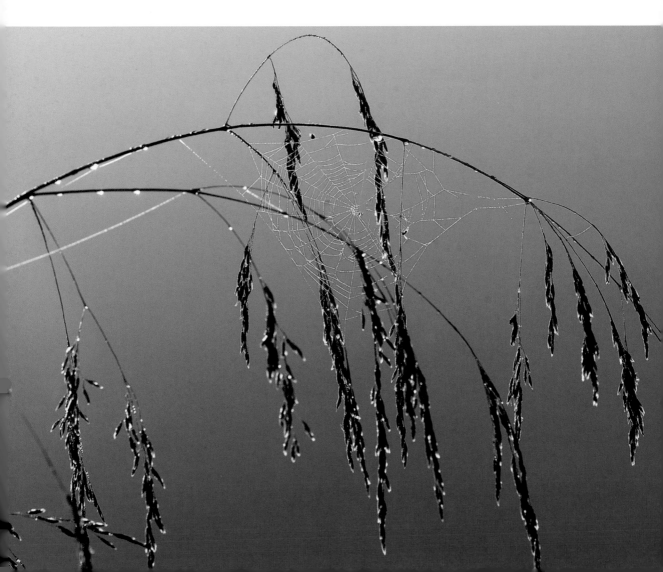

a good, yet cheap introduction to the world of shooting close-ups. Supplementary lenses of this type are lightweight and convenient. They do not affect normal camera functions like metering or autofocusing. Unlike extension tubes, they do not restrict light, so can easily be used handheld. However, as you might expect, there are one or two drawbacks, which shouldn't be ignored. Firstly, single-element supplementary lenses of this type will degrade image quality, causing chromatic aberration (colour fringing). High-quality adaptors boast two elements to minimize this problem, and, while they do cost more, they are well worth considering. Another problem which can afflict supplementary close-up lenses is spherical aberration, which softens the image overall. This will be exacerbated if you use a wide aperture or combine two supplementary lenses. A good basic rule, to minimize spherical aberration, is only to employ apertures narrower than f/11.

Reversing rings

With quality macro lenses growing more affordable it's now less popular to reverse a lens as a way of magnifying a subject. However, the principle is quite simple. The lens is mounted back to front on the camera via an inexpensive adaptor called a reversing ring. This has a rear lens mount one side and a male filter thread on the other, which allows you to attach the lens to the body. You will need to buy a ring which fits the camera mount and also matches the filter thread of the lens you intend using. Reversing an optic in this way creates a close-focusing lens capable of producing good quality macro images at large magnifications, depending on the lens used. Generally, it's best to reverse only short prime lenses, as you may encounter problems focusing, and with image sharpness, if you try reversing a zoom. In most cases the best focal length to reverse is a standard 50mm lens. When using wider lenses, light is restricted at the edges of the frame and dark corners can appear. Although the optical quality is good, the major drawback of using a reversed lens is the loss of automatic metering and focusing. Some lenses will also need another adaptor to keep the diaphragm open. However, specialist companies, like Novoflex, produce reversing rings that retain all the camera's normal features. These adaptors tend to be costly, but enable high image quality at extremely large magnifications.

◀ (cobweb02.tif)
Supplementary close-up lenses may not be able to offer the same quality or level of magnification as some other close-up accessories, but one with a +3 dioptre is ideal for taking pictures of subjects like this small, dewy cobweb.

Nikon D70 with 18–70mm lens, 1/200sec at f/11, ISO 200, tripod

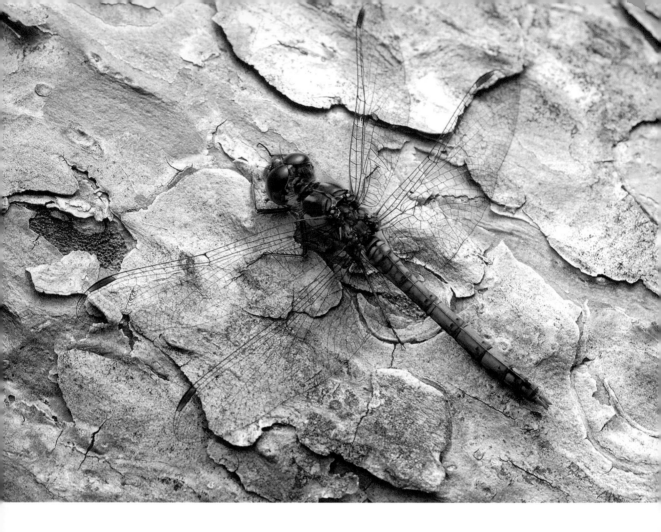

Extension tubes

Extension tubes simply fit between the camera and lens. They are best combined with short lenses, and can be used individually or in combination. Often sold in a set of three lengths of 12mm, 25mm and 36mm, they work by extending the distance between the camera's sensor and lens. This allows for closer focusing, thereby increasing the maximum magnification. With a normal (non-macro) lens the reproduction ratio can be approximated by dividing the amount of extension by the focal length of the lens. For example, 25mm of extension used with a 50mm lens gives a 1:2 reproduction – half life-size – whereas the same extension with a 100mm lens results in a 1:4 reproduction. To achieve life-size magnification, the amount of extension should equal the focal length. This is impractical with lenses above 70mm, so if you wish to achieve high magnifications, use a short lens, although extension tubes are also useful for reducing the minimum focusing distance of longer telephotos. They do not affect image quality, as they have no elements, but they do reduce the light entering the camera. TTL metering compensates for this, but shutter speeds will be lengthened for a given ISO. Another problem can be short working distances when using a lot of extension. This aside, extension tubes are compact and cheap, making them a good alternative or supplement to a macro lens.

◀ (commondarter.tif)

Darter dragonflies enjoy the warmth of wood and often return to the same resting place. A standard zoom, combined with an extension tube, allowed me to get close enough to grab a frame-filling result.

Nikon D70 with 18–70mm lens and PK-13 27.5mm extension tube, 1/125sec at f/10, ISO 400, handheld

Bellows

Camera bellows work on a similar principle to extension tubes. By increasing the distance between lens and sensor, the attached lens can focus nearer. However, unlike tubes, bellows can be employed to achieve a variety of reproduction ratios over a great range. At first glance, they might look old-fashioned, but they're one of the most effective ultra-close-up accessories on the market. On the rear plate of its concertina-style design is a camera mount, with a lens mount on the front plate. Most modern bellows are mounted on a mechanical rail to aid positioning and focusing. Magnification is increased by extending the bellows. Similar to using tubes, more light is lost with greater extension and larger magnifications, and, combined with their bulky, cumbersome design, this means they are not ideally suited for work in the field. Bellows are capable of magnifying a subject far beyond the realms of an ordinary, unassisted macro lens, and can even be coupled with the lens from a microscope. But, at large magnifications, photographers will encounter exaggerated technical difficulties, with limited light, depth of field and focusing. This is why bellows are normally best suited for a studio set-up. Due to their price tag, weight and nature, bellows are not ideally suited to new photographers, but for the more experienced the high magnifications offered are unrivalled.

A right-angle finder is an L-shaped attachment that fits onto a camera's eyepiece, allowing a photographer to view and compose an image by peering downwards, instead of horizontally, into the viewfinder. This is especially useful for close-up photography, as it's often necessary to place the camera in low positions. Due to their specialist nature they're not cheap. However, they can prove invaluable, especially for photographers who suffer from back pain.

jargon busting: **Right-angle finder**

43

▲ (plamp.tif © Wimberley)

The Plamp can be utilized in many ways, but I find it most useful for positioning a small reflector.

▼ (fungi05.tif)

Fungi grow in dark, damp environments, so I used a reflector to add some light underneath the gills. Using a Plamp to position my reflector, I had both hands free to perfect my composition.

Nikon D70 with 105mm lens, 1/2sec at f/22, ISO 200, reflector, Plamp and tripod

Plamp

Shooting close-ups can be a fiddly business, especially if you're trying to angle a reflector in addition to releasing the shutter. The Wimberley Plamp is one solution. Basically, it's an extra arm with a clamp fixed at either end. One clamp fastens to your tripod leg and the other can be used to grasp an object. Thanks to its innovative design and ball-and-socket segmented arm, it can be positioned quickly and easily. This is an accessory aimed specifically at close-up snappers. Mostly, I use the Plamp to position a small reflector, but if it's windy the clamp can be used to hold a flower or branch steady. Equally, it can by employed to pull and hold a plant in a different position; maybe to achieve a more flattering backdrop or to align the subject with the camera's sensor. With extra extensions, it can be lengthened, although it will be less rigid and steady as a result.

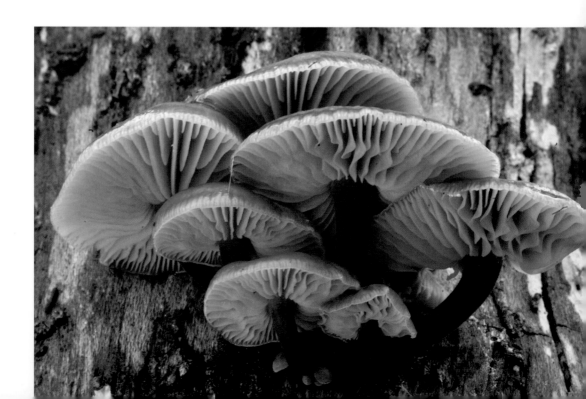

Reflectors

Close-up photographers regularly have to deal with limited light and identify the most practical solution. Flash may be the answer, but, if not applied correctly, artificial light can destroy the natural feel of an image. Alternatively, you can manipulate the available light with a reflector.

I'd argue that a reflector is an essential aid to macro photographers, especially those working regularly outdoors. It couldn't be simpler to use; just unfold and angle it so light is reflected onto the area you require. You can alter the angle to bounce light directly into shade and adjust the intensity of the reflected light by moving the reflector closer or further away from the subject. Most reflectors are double-sided, one side being white and the other either silver or gold. Using a gold reflector will create warm light, but in most situations I prefer the neutral look of a silver or white reflector. Angling a reflector in the correct position, whilst also taking pictures, can prove tricky when you have no one to assist you – this is when an aid, like the Plamp, can prove handy. Avoid placing a reflector too close to the subject, or you risk giving the shot an artificial look.

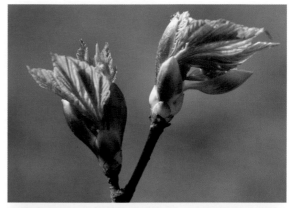

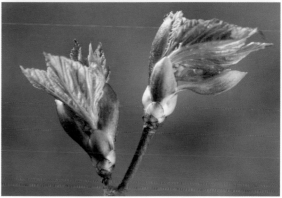

▲ (sycamore01.tif & sycamore02.tif)
I wanted to photograph this emerging sycamore leaf, but the deep shadows created by the midday light meant the bud was lit unevenly. To compensate for this, for the bottom frame, I used a small reflector to balance the available light.

Try making your own reflector. Securely tape a sheet of tin foil – shiny side out – on a sheet of stiff card. You can then use it to bounce light onto your subject.

pro tip

Flash units

I'm sure you're already well aware of what flash is designed to do. It's a very short burst of artificial light which illuminates the subject while the camera's shutter is open. The majority of compact cameras have a built-in flash, and many DSLRs have a pop-up version designed to fire automatically when required. Flash needs to be managed carefully to achieve natural-looking close-ups, especially when snapping natural-history subjects. However sophisticated, a camera's built-in flash can prove quite limited when shooting in such close proximity to your subject. For this reason, many cameras have a hotshoe where a supplementary flashgun can be connected to achieve balanced-looking results. Modern flashguns are sophisticated and can prove an invaluable tool in situations where natural light needs supplementing. Due to the nature of macro work, ring flash units have been designed specifically for shooting close-ups. Basically, they're circular flash tubes which attach to the front of the lens, producing shadowless light. A variant of the ring flash, the twin flash, is also available; both of these are covered in detail in Chapter 4: Light and colour.

Filters

Although filters form an integral part of a scenic photographer's kit, their role is more limited in digital macro photography; but basic skylight or UV filters are handy for protecting the front element of your lens from scratches and moisture. Neutral-density (ND) filters are also useful as they reduce the amount of light entering your camera (without creating a colour cast), allowing longer exposures, which is very useful when you wish to blur water or maybe emphasize the motion of a flower swaying in the breeze. The one filter you shouldn't ever travel without is a polarizer. They're available in two types: linear and circular. You will need to buy the circular type, as these are specifically designed to work with autofocus cameras. Polarizers help saturate colour, especially skies, and also reduce reflections. The effect can be varied by rotating the front of the filter. Close-up photographers will find them useful for saturating skies and reducing glare from foliage and the reflections on water. A two-stop loss of light will result from using one at full polarization, which means they can also be employed as a makeshift ND filter.

pro tip

If using a polarizing filter to saturate a sky, it's most effective to position your set-up around 90 degrees to the sun. Be careful, though: it's easy to over-polarize blue skies, making them look unnaturally dark.

pro tip

Just for the record, I use a Nikon DSLR with 105mm and 150mm macro lenses. I carry polarizing and ND filters, a 12in (30cm) Lastolite reflector, Plamp, scissors and spray bottle in my Lowepro backpack. Depending on what I'm photographing, I use either a Manfrotto or Benbo MK1 tripod.

▼ (hazelcatkins.tif)
The sky can create a natural, clean backdrop. I selected a low angle to photograph these catkins and used a polarizing filter to saturate the clear blue sky.

Nikon D70 with 18–70mm lens, 1/60sec at f/16, ISO 400, polarizing filter and tripod

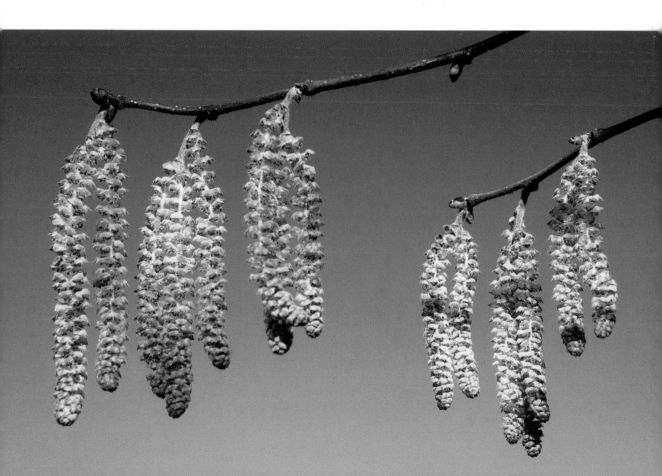

Basic techniques

Exposure

The exposure of an image is the amount of light the sensor is exposed to. This amount is a combination of the shutter speed – the length of time the sensor is exposed to light – and the aperture – the diameter of the hole that the light passes through. The exposure level needs to be very precise: if too much light reaches the sensor the image will be overexposed, appearing too light and with little detail in the highlights; too little light and the image will be underexposed, appearing too dark and losing detail in the shadows. Exposure is regulated by three basic controls: ISO, aperture and shutter speed.

▼ (correct.tif, underexposed.tif & overexposed.tif)
The three shots demonstrate how important it is to achieve the correct exposure. The first frame, of an early purple orchid, is correctly exposed. The second and third pictures are a full stop under- and overexposed respectively.

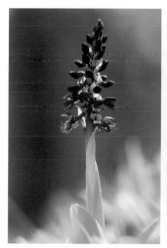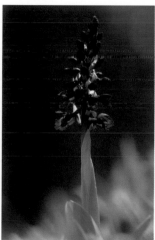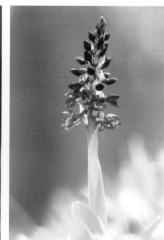

pro tip

If you are unsure of your exposure settings, use your camera's automatic bracketing function. This takes a series of pictures at different exposure values one of which should be correctly exposed.

Reciprocity While there is only one theoretically correct overall exposure value, there are a number of ways that this can be arrived at. For example, if the recommended exposure is 1/60sec at f/8 for ISO 100, a setting of 1/30sec at f/11 for ISO 100 will still produce a correctly exposed result. This ability to alter individual variables while maintaining the same overall exposure is known as the law of reciprocity. Simply put, a change in one exposure variable can be compensated for by an equal but opposite change in another.

Metering

All digital cameras have some form of metering system and most of these are extremely reliable. Depending on the exposure mode that you have chosen the metering system will provide a combination of shutter speed and aperture that should ensure your subject is correctly exposed. There are three principal metering systems on most advanced cameras: multi-segment metering, centre-weighted metering and spot metering.

It is a common mistake to believe exposure is less important when shooting digitally. While some errors can be corrected at the digital-darkroom stage getting complacent is dangerous. For the best results, it is always best to achieve a near-perfect exposure at the taking stage.

Multi-segment metering The easiest system to use is multi-segment metering (the exact name varies with manufacturer). This breaks the scene into multiple sections from which the level of light is measured. These segments are assigned an importance, according to their position, the position of the subject, the distance of the subject and the colour (all depending on the complexity of the camera's metering system), then an algorithm provides a reading for the entire scene. The accuracy of this system depends on how sophisticated your camera is. However, it can usually be relied on for most situations.

Centre-weighted metering Centre-weighted metering takes the meter reading from the central circle of the frame (this is marked in the viewfinder of many cameras). This reading is given the majority of the weighting, but some consideration is given to parts of the frame lying outside the circle. This is a useful mode for shooting subjects that fill the centre of the frame.

Spot metering The most precise form of metering, but one that requires the most work from the photographer. It takes a very small reading from the central area of the frame or an area linked to an autofocus point. This allows you to meter a specific area that you know to be mid-tone (see below), which can be useful in high-contrast scenes.

ISO

The ISO rating was discussed on page 15, but it is also worth looking at again as it is the foundation of the exposure equation. The lower the ISO value is the less sensitive the sensor will be to light, therefore the more light you will need to achieve the same exposure. Again, a doubling and halving of the ISO value is equal to a one-stop change. For example, a one-stop decrease in the ISO value from ISO 200 to ISO 100 will require a one-stop increase in the aperture or a one-stop decrease in the shutter speed to balance it. This means that you can adjust the ISO value in order to allow a different combination of variables to be used. For example, a higher ISO value will allow a faster shutter speed for a given aperture.

Metering systems work on the assumption that a scene contains a range of tones based around a mid-tone, which reflects the equivalent amount of light to 18% grey. This is the case in the majority of circumstances; however, subjects that are significantly lighter or darker than mid-tone may cause the metering system to underexpose or overexpose the image respectively.

jargon busting: **Mid-tone**

Aperture and depth of field

The aperture is the variable hole in the lens through which light enters the camera. Although the range of apertures varies from one lens to the next, a typical spread may be from f/2.8 at its widest to f/32 or above at its narrowest. The higher the f-number the smaller the aperture, because the f-number represents the aperture's diameter as a fraction of the focal length, hence f/32 – 1/32 of the focal length in use – is smaller than f/16 – 1/16 of the focal length. All modern lenses can have their aperture selected via the camera body, but some also have a ring that can be rotated. While the shutter speed determines how motion is depicted in an image, aperture (along with two other variables, see page 63) determines depth of field – the amount of an image from foreground to background that appears sharp. The narrower the aperture the greater depth of field, while the wider the aperture the shallower depth of field.

Aperture and compact cameras Because compact cameras have very small sensors they only require very short focal lengths. This means that the depth of field is naturally very great and they only require a limited range of apertures to maintain it.

Depth-of-field preview button Regardless of the aperture selected, a lens works at its widest aperture until the shutter is released, allowing the camera to focus and providing a bright viewfinder. Therefore, what you see through the viewfinder isn't a true reflection of the depth of field, so, many DSLR cameras are designed with a depth-of-field preview button. Normally located near the lens mount, the button closes the aperture to that which is set, showing the amount of the image, from near to far, that's in sharp focus. At small apertures the viewfinder will appear quite dark, making it tricky to ascertain what is in or out of focus. Even so, for close-up photographers the depth-of-field preview button is hugely beneficial.

Aperture-priority mode is a semi-automatic exposure mode, which allows the photographer manually to select the aperture, while the camera sets the shutter speed to produce a correct exposure. It is useful when you wish to have full control over the depth of field, perhaps to ensure that the whole of the subject is sharp or to throw a distracting background out of focus.

jargon busting: Aperture-priority

▶ (emergingdamselfly.tif)
By using my camera's preview button, I was able to check the depth of field. I found an aperture of f/13 produced the perfect balance, giving me enough depth of field to keep the damselfly, case and reed in sharp focus, while diffusing the background.

Nikon D70 with 150mm lens, 1/30sec at f/13, ISO 200, tripod

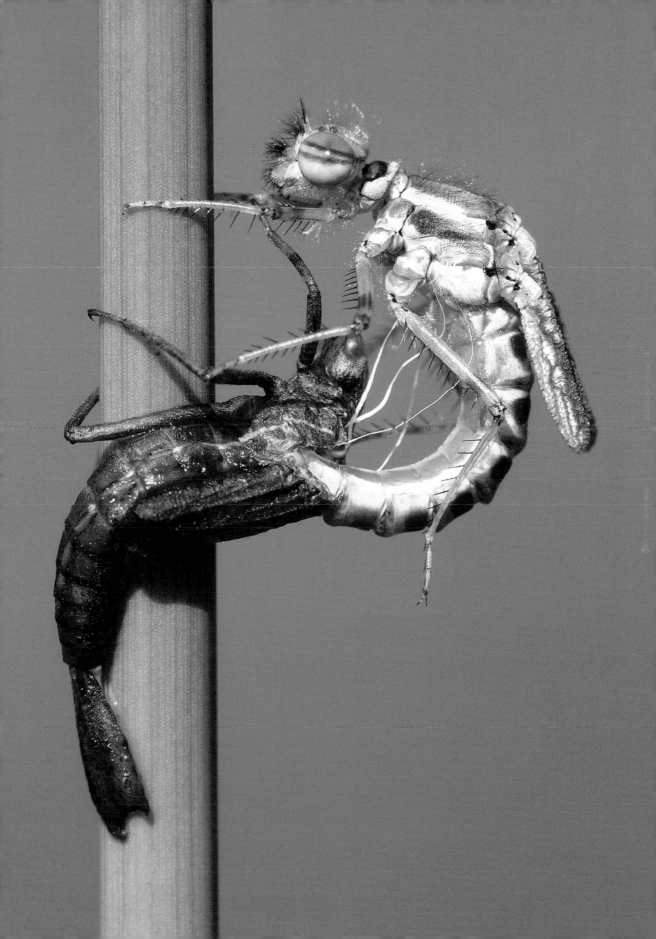

Shutter speed and motion

Shutter speeds denote the length of time the camera's shutter is open, exposing the sensor to light. They are adjustable, and each doubling or halving is equal to a one-stop exposure change; digital cameras allow you to select intermediate settings, normally third- or half-stops for added precision. Most cameras have a range of 1/8,000sec to 30 seconds, although this can be lengthened to minutes using the bulb setting.

Shutter speed controls the appearance of motion in an image. The faster the shutter speed the faster the movement you will be able to freeze – faster shutter speeds also help eliminate blur caused by camera shake. Alternatively, a slower shutter speed can be selected to emphasize subject movement. Combined with the right subject, like flowing water or a flower being blown in a breeze, this can be an effective technique to add life to your images. Obviously, the shutter speed you select is affected by the light available and the aperture being used.

Bulb setting Most cameras offer a bulb setting that can be selected by choosing a shutter speed longer than the camera's slowest value (normally 30sec). This enables you to hold the shutter open by keeping the shutter-release button depressed. It is useful for low-light photography, but can be very hit-and-miss as you will have to assess the light for yourself, and you should bracket heavily. Macro photographers rarely need to use exposures of this length, and I've never used the bulb setting for a close-up image.

Camera shake This irritating phenomenon occurs when the shutter speed isn't fast enough to eliminate your natural movement. At worst, the image will appear totally blurred; at best the shot will be soft when enlarged. Camera shake is only a problem when taking pictures handheld, and the problem can be exaggerated by long lenses and high magnifications.

Some DSLRs have the facility to 'lock up' the camera's reflex mirror prior to taking pictures. An SLR camera generates a degree of internal vibration or 'slap' whenever the shutter is triggered. This is caused as the mirror swings upwards and then as the mechanical shutter opens and shuts. At long exposures, this can adversely affect picture quality. Unfortunately, shooting at high magnifications also exaggerates faults like this, but, by locking the mirror, internal vibrations will be substantially reduced. If your camera has this facility, use it whenever necessary.

jargon busting: **Mirror lock**

We all know it's not always possible to use a camera support, but there are a few rules you can follow to combat the effects of shake. It's very easy to overestimate how steady you can hold a camera, but generally speaking you should always employ a shutter speed that is at least equivalent to the focal length in use; for example, a shutter speed of 1/200sec if you are using a 200mm lens. With heavier lenses or when working at high magnifications you should use an even faster shutter speed. If you have a lens with anti-vibration technology, use it; sharp images can be produced at speeds two or three stops slower than using a lens without. Alternatively, you can increase the ISO or aperture to allow a higher shutter speed. You can also limit the effects of shake through the way you stand and hold your camera (see page 56).

▼ (camerashake01.tif & camerashake02.tif)
I noticed this common lizard basking on a fence, but due to its position, I had to shoot handheld. An aperture of f/14 created a shutter speed of 1/30sec, but, at this magnification I was unable to keep steady. I compromised with a wider aperture and a setting of 1/320sec at f/5.6 – fast enough to prevent shake.

Shutter-priority mode is a semi-automatic exposure mode, which allows the photographer to manually select the shutter speed, while the camera sets the aperture to produce a correct exposure. Shutter-priority mode is useful when you wish to have full control over the shutter speed, for example, to blur water or freeze rapid action.

jargon busting: **Shutter-priority**

Close-up on/ handholding your camera

UNFORTUNATELY, IT IS NOT ALWAYS PRACTICAL TO USE A CAMERA SUPPORT AND WHILE YOU SHOULD TRY TO AVOID SHOOTING HANDHELD IT IS SOMETIMES UNAVOIDABLE. SO HERE ARE A FEW TIPS TO HELP YOU.

▶ (standing.tif)
To minimize movement when standing, photographers should place their feet shoulder-width apart with one slightly in front of the other. Keep your elbows to your chest and hold the camera firmly to your face. Hold it with both hands, and gently squeeze the shutter-release button. When possible, brace yourself against a tree or fence.

▶ (kneeling.tif)
Kneeling is more stable than standing, and resting your elbows on the ground also helps. If this isn't possible then employ a similar technique to what you would use if you were standing. Press your elbows against your body and your camera firmly against your face to minimize instability.

Damp knees can be a real problem if you are kneeling down for long periods of time, so carry a bag or mat in your camera bag. However, be aware that this will only work if your subject isn't easily disturbed by the noise it causes.

▶ (lyingprone.tif)
To achieve good, natural-looking wildlife images, it's important to keep the camera level with the subject. For plants and insects near the ground, this can mean shooting from a prone position. Beanbags are handy, but, if you don't have one, simply use your elbows for support. Lying flat on the ground limits body movement, so it's a stable position, but use a ground sheet to avoid getting damp and muddy or lying on any nasty prickles.

pro tip /

Compact users should avoid composing handheld shots via the camera's LCD monitor. By holding the camera away at arm's length, you're exaggerating your natural movement.

(standing.tif)

(kneeling.tlf)

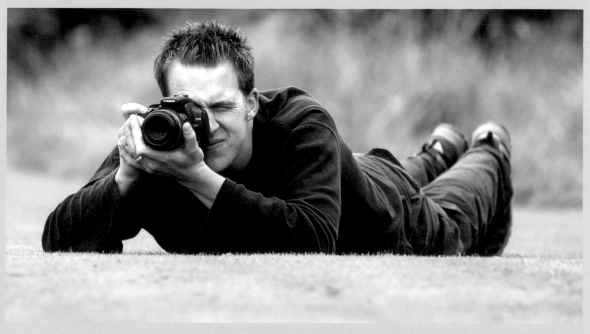

(lyingprone.tif)

Composition

Composition is the term we use to describe the way we visually arrange and balance the key elements within our camera's viewfinder to form a strong, memorable image. Yes, there are guidelines that photographers use, but there are no undisputed rules. Composition is subjective and there is no obvious right or wrong; a composition I find pleasing, you may not… and vice versa.

Basic elements of composition

Although we may not be aware we're even doing it, every time we draw our attention to something we find interesting, we're creating a picture in our imagination. We do this automatically, so why should composing an image through a viewfinder be any different? I believe photographers should trust their instincts. I often find that the most pleasing composition is the one I naturally frame when I first look through the viewfinder.

Composition will also often be dictated by the shape and size of the subject, and close-up photographers will instinctively wish to fill the frame with their subject. However, depending on the subject matter, sometimes a more subtle approach is required. By taking images from a little further away, and leaving a percentage of the frame empty, a photographer can often produce a more striking image by invoking the power of suggestion.

It's possible to photograph exactly the same subject, using different compositions, to produce a series of very differing results. So here are a few basic guidelines you may find helpful:

- Identify the primary point of interest before you begin taking pictures. Once this is established, you can arrange the shot so that the various elements complement and draw attention to your focal point.

- Keep it simple. Be careful not to complicate images by including clutter or anything which isn't integral to the image. This will only weaken the resulting shot.

- If you wish to isolate your subject, but cannot find a suitable angle, manipulate the depth of field to throw the background and/or foreground out of focus.

- Bold lines often appear more dynamic when positioned diagonally instead of parallel to the edges of the frame.

- Empty space, left to add impact and drama to a shot, should be left in front of the subject so it appears to be moving into, rather than out of, the frame.

Rule of thirds

One of the basic compositional tools is the rule of thirds. By positioning key elements of your composition in the middle of the frame, you'll often weaken the resulting shot by making it appear static. The 'rule' of thirds is really a compositional guideline, which photographers often adopt to help create the strongest composition. Imagine an image divided into horizontal and vertical thirds to create a grid. Positioning important elements of your composition on one of the four intersecting points will often produce a striking result.

The rule of thirds is as relevant to close-up work as it is to other areas of photography and you'll be surprised how often it works. Remember, though, that as useful as this it is, it's still only a guideline. There will be times when it should be overlooked altogether. For instance, if you're photographing a symmetrical subject, like a flowerhead, quite often a more striking image can be produced by placing its mid-point in the centre of the frame. Ideally you should assess each potential image individually, and with time the art of composing an image will become instinctive.

▼ (dahlia.tif)
In this instance, I decided it was best to ignore the rule of thirds, and placed the flower's mid-point in the centre of the frame, creating a symmetrical image.

Nikon D70 with 150mm lens, 1/6sec at f/18, ISO 200, tripod

▶ (largereddamselfly.tif)
(Following page) I composed the damselfly and flower roughly on intersecting thirds creating a stronger image than if I had placed it in the centre.

Nikon D70 with 150mm lens, 1/160sec at f/5.6, ISO 200, tripod

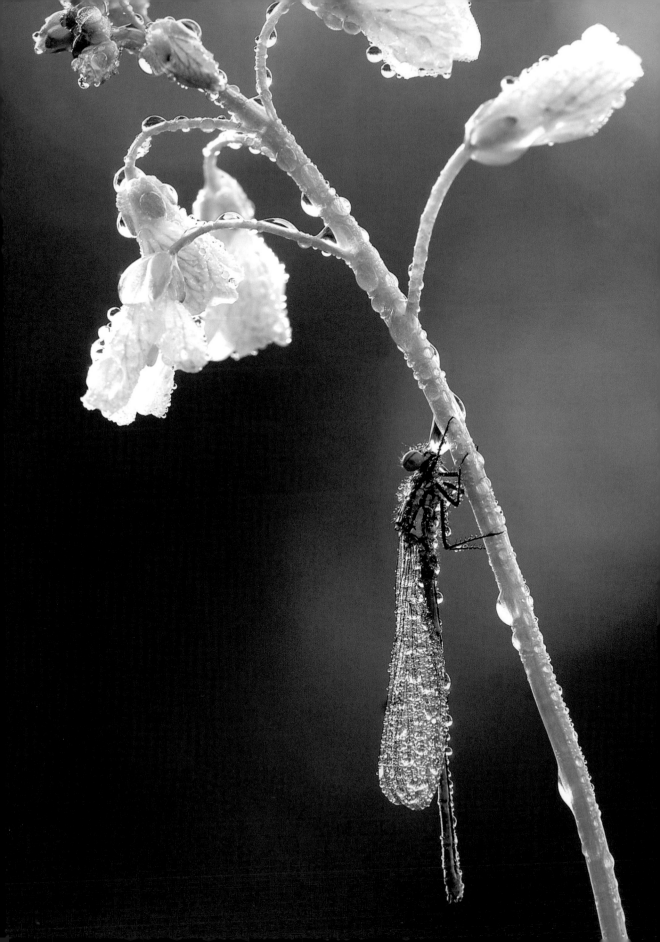

Orientation

One of the first decisions a photographer faces is which format will suit the subject best: a vertical or horizontal composition? It's a decision which will greatly affect the aesthetics of the resulting image. Even so, I still meet photographers who rarely, if ever, turn their camera vertically, and a good image is often weakened because the photographer has failed to adjust the camera to suit the subject. If in doubt, it's wise to take pictures using both formats for later comparison. On the other hand, the composition can be dictated by the subject that you're shooting. For instance, an orchid will normally suit a vertical composition, whilst it's best to hold the camera horizontally if snapping a butterfly resting with its wings open. Having said this, dramatic results can be created by employing the frame unexpectedly. Remember, a vertical composition will accentuate height, and a horizontal format will emphasize width. When used correctly, this can create original results. Don't always fill the viewfinder with your subject; think carefully about what will create the most striking image.

▼ (marbledwhite01.tif)
I found this marbled white butterfly early one morning. The most obvious approach was to select a vertical composition, move in close and fill the frame.

Nikon D70 with 150mm lens, 1/100sec at f/5.6, ISO 200, tripod

▼ (marbledwhite02.tif)
I changed format and moved further away, to show the butterfly clinging precariously to the flimsy grass. Despite the empty space, I much prefer the second frame.

Nikon D70 with 150mm lens, 1/100sec at f/5.6, ISO 200, tripod

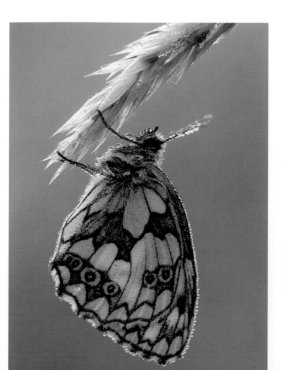

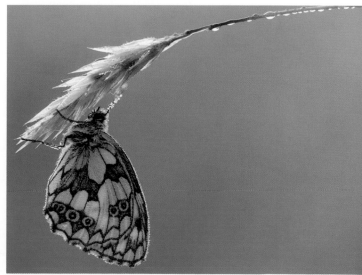

▲ (flower01.tif)

It was a breezy afternoon when I tried to photograph this colourful flower, so I knew I'd need a quick shutter speed to freeze its movement. The resulting large aperture created a shallow depth of field, but, in this instance, it's helped to isolate the flower.

Nikon D70 with 70–300mm lens, 1/400sec at f/5.6, ISO 200, handheld

Capturing motion

We've already touched upon the technicalities of shutter speeds, but they can also be used creatively to stop or enhance the motion of our subject. Freezing movement requires a fast shutter speed; how fast depends on the speed of the motion: 1/300sec might be enough to freeze the movement of a flower in a breeze, but not to capture the spray of water flowing over a weir. With a little experience, you can estimate the shutter speed required; however, if in doubt, experiment with various speeds. Obviously, shutter speed affects the corresponding aperture, and a fast shutter speed will need to be coupled with a large aperture, reducing depth of field. In some situations, it will be necessary to compromise or use a higher ISO to achieve the shutter speed needed, while maintaining a workable depth of field.

Although photographers often strive to freeze movement, there are times when blur can create a sense of motion, mood or unreality. Creating the right effect can be tricky: too much motion, and detail will be indistinguishable; too little, and it will look unintentional. It's a fine balance, but the LCD monitor allows you to check the effect. A tripod is essential when using slow speeds, so that you don't add your own movement to the subject's. Presuming that the subject isn't static, pictures taken using shutter speeds slower than 1/10sec will show signs of motion. However, sometimes an exposure of several seconds might be required, depending on the effect you wish to produce.

Depth of field

The depth of field is the zone in front and behind the point of focus that is acceptably sharp. It is managed by the aperture, the focal length of the lens used and the subject-to-camera distance, and can be depicted in different ways by altering these variables.

We've already touched upon the relationship between aperture and depth of field. Simply, a large aperture (small f-number) will create less depth of field than a small aperture (large f-number). So, if you wish to draw attention to just one part of your subject, use a large aperture to throw the rest of the frame out of focus. If you wish to achieve front-to-back sharpness, use a small aperture. Unfortunately, in reality it's not quite this straightforward. Photographers will often have to juggle depth of field with selecting an appropriate shutter speed; depending on the situation, a compromise often has to be made.

The focal length of the lens also affects depth of field. The shorter the focal length, the greater the depth of field for a given aperture at a particular shooting distance. Longer lenses offer limited depth of field, making them great for isolating subjects. The subject-to-camera distance is of huge significance to close-up snappers, as at short working distances depth of field is shallow, and accurate focusing and aperture selection is critical. You can manipulate depth of field to influence the composition: a shallow depth of field can emphasize all or part of the subject, whilst back-to-front sharpness will help capture it in context.

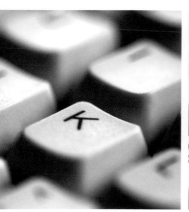

▲ (keyboard01.tif, keyboard02.tif & keyboard03.tif)
Keeping the point of focus on the 'K' for each frame, while selecting different apertures shows the effect on depth of field in close-ups. In the left-hand shot an aperture of f/2.8 keeps only the 'K' sharp, while the middle shot (f/11) has greater depth of field only the right-hand image (f/22) renders everything sharp.

Positioning the point of focus

Photographers have the ability to draw attention to just a single point, simply through the creative use of shallow depth of field. By employing a large aperture at a relatively high magnification ratio, the resulting depth of field will be shallow; maybe no more than a few millimetres. The shallower the depth of field, the more critical the exact point of focus becomes. This is because everything before and beyond this point will be rendered soft, drifting progressively out of focus. Precise focusing can highlight a small area of the frame, with the contrast between blur and detail, pulling the eye of the viewer towards the photographer's intended point of focus.

Selecting the exact point of focus can prove a dilemma. Often it will be obvious, but with shallow depth of field there can be plenty of choice. Making a final decision can prove tricky. For instance, if you wish to photograph a flower close-up, utilizing a restricted depth of field to create an artistic result, where should you focus: the stamens, petals or midway? As a general rule, the soft, yet still recognizable part of the image should be in the background. In this instance, if the point of focus is on the petals, the blurred stamens in the foreground will unintentionally draw the eye and prove distracting. While a focal point midway would emphasize nothing of significance. Remember, the point of focus should highlight the most significant and visually interesting area of the image. However, by focusing on the stamens, the eye is immediately drawn to that point, whilst the rest of the flower, although out of focus, is still recognizable and complementary. By depressing the depth-of-field preview button, photographers can check the true distribution of sharpness and blur, adjusting the selected aperture to increase or decrease depth of field as necessary.

The hyperfocal distance Many photographers remain unaware of the hyperfocal distance and its significance. Basically, it's the point of focus where photographers can achieve maximum depth of field for any given aperture. Identifying this point is important if you wish to obtain front-to-back sharpness. When a lens is focused at the hyperfocal distance, depth of field extends from half this point to infinity. Being able to calculate this distance is especially important for landscape photographers, who regularly require a large depth of field to capture sweeping vistas. However, close-up snappers will also find it helpful, especially in situations where they want to show a foreground subject in close-up but still in the context of its surroundings. Identifying and using the hyperfocal point will help you keep the distant background acceptably sharp, and is most effective when using short focal lengths combined with a small aperture.

The most practical way of estimating the hyperfocal point is to use your camera's depth-of-field preview button, see page 52. First of all, focus your lens on infinity, then depress the depth-of-field preview button. The closest point remaining in focus is the hyperfocal point, which you should now focus on to maximize depth of field. Alternatively, if your lens has a depth-of-field scale you can simply align the infinity mark against the aperture that is in use.

▶ (thorn.tif)

I deliberately selected my macro lens's widest aperture to create a very shallow depth of field. I then placed the point of focus on the top-left thorn, ensuring it was positioned on an intersecting third to add strength to the composition.

Nikon D70 with 105mm lens, 1/1,600sec at f/2.8, ISO 200, tripod

▼ (stamens.tif)

By utilizing a limited depth of field and focusing on this flower's stamens, I've thrown everything else into soft focus. Despite this, the identity of the flower is still recognizable.

Nikon D70 with 105mm lens, 1/125sec at f/2.8, ISO 200, handheld

Light and colour

Natural light

The word photography literally means 'drawing with light'. To be able to take consistently good photographs, you need to be able to control and exploit light, and the way in which a photographer employs light is absolutely key to an image's success. The quality of natural light is dictated by the sun's position, the time of day and the season. Photographers need to have a good understanding of this to ensure they match their subject with the right conditions.

Direct sunlight

Natural light is continually changing; it's not simply the sunlight's direction and intensity which alters, but also its colour temperature. At either end of the day, there is a higher proportion of red and yellow light in direct sunlight. The warmth this creates can look very pleasing, which is why many photographers advocate taking pictures during early morning and late evening. It's also good advice, because light at this time of day also casts longer shadows, which accentuate form. This is important, as shadowless images can look flat and lifeless, which is why strong, overhead light is best avoided. For this reason, I rarely take pictures outside during the middle of the day if it's bright and sunny. Having said this, in late autumn, winter and early spring the sun doesn't climb so high in the sky and the warm, low-angled light can be utilized for shooting close-ups throughout the day.

Traditionally, front lighting, where the sun is positioned behind the photographer, is thought to be the best suited to photography, as it illuminates the subject evenly. However, the light can sometimes prove too flat, as the shadows fall behind the subject. Shadows cast to one side, created by slight side lighting, help restore depth and enhance the three-dimensional feel of your pictures. Beware, though, that strong side lighting can exaggerate shadow, creating too much contrast – try using a reflector to bounce a little light back onto the subject.

The auto white-balance mode of some cameras may compensate for the warmth of the evening light, thereby forfeiting its attractive quality. So, instead of setting the white balance to auto, try daylight, cloudy or shade modes for progressively warmer effects. Alternatively, shoot in raw format and adjust the white balance on computer.

pro tip

▼ (commontoad01.tif)

I positioned this toad so it was lit from the side. The shadow created helps highlight the creature's warty, rough-textured skin, adding depth and a three-dimensional feel to the image.

Nikon D70 with 150mm lens, 1/800sec at f/4.5, ISO 400, handheld

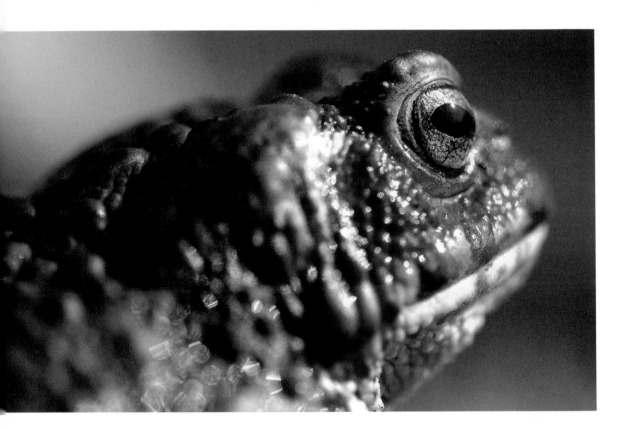

For close-up images, bright, overcast lighting is arguably the most underestimated form of natural light, often proving the most consistent and flattering, regardless of the month or time of day. A thin layer of cloud can soften sunlight and reduce contrast, making it easier to photograph dark and bright subjects. Overcast light is especially well suited to photographing plants, when a fast shutter speed isn't essential. The glare from vegetation, is reduced, so colours appear more saturated; and some blue flowers, like bluebells, actually reflect invisible ultraviolet radiation that can create a purple colour cast in pictures taken in bright, direct sunlight. Colours can be captured with greater accuracy in overcast light, so don't be deterred if the sun isn't shining.

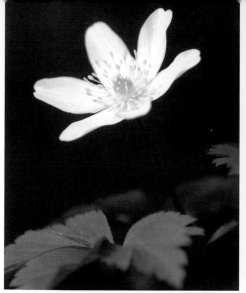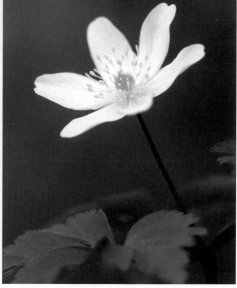

▲ (woodanenome01.tif & woodanenome02.tif)

It can be tricky to photograph very dark and light subjects in bright, direct sunlight. Due to their reflective nature, the delicate, white petals of this wood anemone look washed out in the first image. As a result, fine detail is lost. In the following frame, the sun has vanished behind a cloud, diffusing the light. This has allowed me to capture accurate detail. Notice also, that the colour of the vegetation is more saturated because its leaves are less reflective.

Here's a good, basic rule, which I was taught a few years ago. If your shadow is longer than you are, the sun's low enough in the sky to be suitable for photography.

pro tip

Window light Still-life photography is often associated with complex lighting and elaborate flash set-ups. Understandably, many photographers find this off-putting; however, for the majority of subjects, simple window light is quite sufficient. The colour, intensity and direction of the light flooding through your windows will alter depending on the weather. You just need to match the right object to the conditions. If it's overcast, the light will be naturally diffused and soft, which is normally the most flattering. However, if you'd prefer direct, bold light, use a brightly lit window preferably during the early morning or late afternoon, arranging your set-up on a window ledge, adjacent table or work surface. If you wish to diffuse very harsh light, hang a net curtain or some muslin over the glass pane. You can even tape coloured gels to the window to alter the light's colour.

Backlighting

Backlighting is simply the technique of positioning the principal light source behind the subject, and outdoors this means shooting towards the sun. Used appropriately, it is a way of emphasizing a subject's form or highlighting the intricacy of translucent subjects, like the veins of a leaf. Although a flashgun can be positioned behind a subject to give it the appearance of being backlit, natural light is preferable. The sun should be low in the sky, so morning and evening are the best times of day. You then need to angle your set-up so the light illuminates the subject from behind.

By shooting towards the light, your camera's metering can become erratic. To deal with this, you could bracket (see page 49) to guarantee a correct exposure. Alternatively, take a spot meter reading from a suitable area of the subject, and check the resulting histogram.

Flare is also likely to present a problem. Modern optics have surface coatings to combat its effects; a lens hood will help limit stray light. If you can see its effects through the viewfinder, it's normally possible to eliminate it by altering your position. Use a lens hood or shield the lens with a sheet of card or your hand, but avoid your shield becoming part of the picture. It's also worth depressing your depth-of-field preview button, as the effect varies with the aperture. Although lens flare can be used creatively, it is normally undesirable.

▼ (bracken.tif)
The light illuminating this dead bracken frond, created a colourful contrast to its inky backdrop. At another time of day, with the sunlight in a different direction, this subject wouldn't have been worth snapping. I bracketed to ensure a correct exposure.

Nikon D70 with 150mm lens, 1/50sec at f/11, ISO 200, tripod

▶ (flysilhouette.tif)

It's possible to create a silhouette by photographing your subject through a backlit, translucent layer. I noticed this fly resting on a blade of grass; by carefully positioning myself I was able to show its outline. This produced a more original, interesting result.

Nikon D70 with 150mm lens, 1/160sec at f/7.1, ISO 200, tripod

Silhouettes A silhouette is the most extreme form of backlighting, where the subject is rendered as a black shape, without colour or detail, against a lighter background. Many subjects look good in silhouette; you just need a little imagination. However, it's important to select one with a strong outline, so it remains recognizable.

While you can create silhouettes at any time of the day, it's best to shoot at dawn or dusk. With a low sun the colours in the sky can be striking, making it easier to create a strong contrast between the subject and its background. To enhance warm colours further, why not set your white balance to cloudy or shade. Achieving the right exposure should be straightforward: simply meter from the background/sky as opposed to the subject itself. If in doubt, bracket your exposure by a full stop either side of the recommended setting.

When shooting silhouettes or backlit images, be careful not to point your lens directly at the sun, you may damage the camera's sensor and even your eyes.

pro tip ⊕

Artificial light

Of course, natural lighting is not always sufficient; it sometimes needs supplementing. But artificial light has to be used with care, as flash can easily destroy a natural appearance. However, used correctly, a burst of flash helps capture otherwise impossible images.

Integral flash

The majority of cameras are designed with an integral flash. If you're using one of your camera's automatic functions, then this will activate when the natural light is inadequate, alternatively; it can be selected whenever you require. Your camera's built-in flash is capable of surprisingly good results. However, don't shoot subjects too close to the lens, as the flash will simply pass over the top or the lens will cast a shadow across part of the image. The latest built-in flashes pop up higher above the viewfinder than previous ones, but this is still a problem.

Built-in flashes are very handy if you find yourself in a situation where the ambient light is insufficient. However, they're no substitute for a dedicated flashgun, which can be used off-camera, bounced or diffused for greater creative control. A built-in flash is most useful at reproduction ratios below half life-size. It is possible to vary the flash output by using flash exposure compensation and selecting various flash sync modes, see page 79.

A flashgun's power is denoted by its guide number (GN). Modern flashes are sophisticated, so normally you need not worry about the flash-to-subject distance. However, it is worth noting that the GN denotes the maximum coverage (normally in metres or feet) for a particular ISO rating (normally ISO 100). To give you an idea of how the GN affects the exposure you can use the following equations:

aperture = GN / distance *and* **distance = GN / aperture**

So a flashgun with a GN of 112/34 (ft/m at ISO 100) used at f/11 should have the subject no more than roughly 10ft or 3m away. Unfortunately, the calculations used to establish a flashgun's GN are not standardized, which can make it tricky to compare units.

jargon busting: **Guide numbers**

▶ (withoutflash.tif)

I found this marbled white butterfly preparing to overnight late one evening. With the sun so low in the sky, a shot using the little natural light available proved too dark with a cold, blue colour cast.

Nikon D70 with 150mm lens, 1/30sec at f/6.3, ISO 200, tripod

▶ (withflash.tif)

Using a burst of flash from the built-in flash proved too harsh. The white scaling in the middle part of the butterfly's underside is washed out and the lighting looks artificial.

Nikon D70 with 150mm lens, 1/30sec at f/6.3, ISO 200, built in flash, tripod

▶ (diffusedflash.tif)

I taped some clear tissue paper over the camera's flash, to act as a makeshift diffuser. This softened the light and created a far more natural feel. I had to increase exposure time slightly to compensate.

Nikon D70 with 150mm lens, 1/10sec at f/6.3, ISO 200, diffused built in flash, tripod

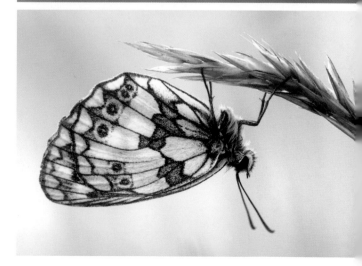

External flashguns

There are many types of external flash available, which vary in design, strength and sophistication. Most are auto-electronic systems which operate by exchanging information between the flash unit and the camera; these are known as dedicated units and are well worth the extra cash. They can be attached to the camera itself, via its hotshoe, although, like a built-in flash, this can produce quite flat, uninteresting light. It's normally preferable to attach the flash to a specific bracket or macro arm so it can be used off-camera (via a connecting cable). By doing this, it's possible to simulate a more natural angle of light. You may even wish to position the flashgun below, overhead or behind the subject to create a more dramatic effect. Most modern flashguns are designed so the head can be rotated and angled. This allows photographers to direct the light with precision or bounce the burst to soften its effects – do not bounce light off a coloured surface, or you will create a colour cast of that particular hue. Many external flash units have a high guide number, meaning they're effective over a large range. However, even small speedlights with a modest GN will prove sufficient when working close to the subject.

The drawback of using a single unit is that, without diffusion, it can produce quite harsh shadows. Naturally, the greater the angle the flash is positioned in relation to the subject, the longer shadows will be. If required, a second flash unit can be used (fired simultaneously using a slave unit) and positioned so that it 'fills in' this shadow. The second unit should be programmed to fire a weaker burst, say two stops less than the main flash. However, photographers will be unable to justify the cost of a second flash unless they will use it regularly. But in close-up you can carefully position a small reflector (or white card) opposite the flash, and bounce light back into the shadows. A diffuser should also be used to reduce the harsh quality of flashlight (see page 78).

◀ (maple.tif)
Due to the dull conditions, the fastest shutter speed available to me wasn't sufficient to freeze the slight movement of these maple leaves, caused by the morning breeze. I didn't wish to increase the ISO sensitivity to compensate, for risk of degrading image quality. Instead, a burst of flash proved the perfect solution.

Nikon D70 with 150mm lens, 1/100sec at f/3.2, ISO 200, SB800 speedlight, tripod

▲ (redhotpoker.tif)

To shoot this arty flower close-up, I had to position the camera extremely close to the plant. This blocked the natural light and necessitated the use of a macro flash, employing a flash compensation of −1Ev to help retain the flower's warm, strong colours.

Canon 350D with 60mm lens, 1/80sec at f/2.8, ISO 100, macro flash, tripod

Macro flash

Working in close proximity to the subject makes it difficult to position conventional flashguns. However, macro flashes are designed to make the job easier. The are two main types: ring flashes and twin flashes.

Ring flash Unlike conventional flashguns, a ring flash is circular and attaches to the front of the lens, while the control unit sits on the camera's hotshoe. This enables the flash to illuminate close subjects; however, it can produce flat light that is ideal for cataloging and medical photography, but can be disappointing for creative shots. To overcome this, some ring flashes have more than one flash tube, and the output ratio can be varied between them. Alternatively, black tape can be used to mask parts of the ring, varying its output.

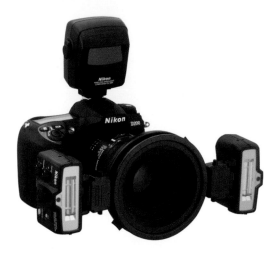

▲ (nikonsbr200.tif © Nikon)

The Nikon SB-R200 is a lightweight and compact twin flash. It can be coupled with another unit, inserted into a dedicated ring (attached to the lens) and used to direct light precisely onto small subjects. It can be controlled through a specific controller unit or fired via the camera's integral built-in flash.

Twin-flash units These work on a similar principle to a ring flash. Instead of a single ring they consist of two individual heads that are mounted on a ring, attached to the front of the lens. As with a ring flash, the output can be varied between the heads; however, they have the added flexibility of being able to move independently. They can even be removed from the mounting ring altogether, to be handheld or attached to, for example, a tripod. The flash heads can be fired together or individually, providing even greater lighting flexibility and creative possibilities. They're light and compact, and are arguably the most versatile form of flash available to outdoor macro photographers. However, they do also produce twin catchlights, which can look unnatural, and they are generally more expensive than other forms of flash.

Off-camera flash arms

Although flash can provide nice lighting, it can create harsh shadows. By positioning the flash unit it's possible to reduce or exaggerate shade. To try to eliminate shadow, the flash is best mounted above and directly behind the optical axis – casting shadows behind and below the subject, making them shorter and less apparent. However, this can create flat light; often it's more desirable to position the flash to one side of the lens, using a purpose-made bracket, to cast shadows in one direction and create more depth.

Off-camera flash arms, or brackets, are designed to keep the head a reasonable distance away from the lens, enabling better control of shadows. Flash arms for close-up work are produced by the likes of Wimberley, Novoflex and Manfrotto, and design and flexibility vary depending on the make and model. Most have two adjustable arms or rods extending from the base plate. It's possible to attach a flash unit to each arm, and, by synchronizing the flash bursts, photographers are able to illuminate the subject from two angles. Flash units can be arranged to replicate the effect of a twin-flash unit, if you wish. However, the flexibility of the adjusting rods makes it possible to position the flash bursts at almost any angle.

Lightboxes

If, like me, you're a digital convert from transparency film, there's a good chance you will own a lightbox. For those that aren't already familiar, lightboxes are simply units with daylight-balanced tubular lighting mounted below Perspex or toughened glass, designed for viewing transparencies and negatives. Their light is diffused, making it well suited to close-up work, as by laying translucent objects on a lightbox it's possible to create beautifully backlit images.

If you have a lightbox it's best to place it on the floor, or at low level, so you can position your camera over it. It's possible to shoot many different objects; try photographing a leaf, slices of fruit, ice, coloured glass, clear plastic, or even cross-polarized shots (see page 84), but be careful with wet subjects as a lightbox is after all an electrical device. Before you begin taking pictures, I suggest you switch the room lights off so the white balance isn't confused by conflicting light sources. If you wish to experiment with various colour casts, buy gels from a local craft shop and place them between the lightbox and your subject.

▼ ► (freezing01.tif & freezing02.tif)
A lightbox can help create high-key images. I'd frozen this leaf in a clear water-filled dish. Metering the leaf caused the ice to overexpose, creating a striking result.

Nikon D70 with 105mm lens, 1/6sec at f/11, ISO 200, tripod

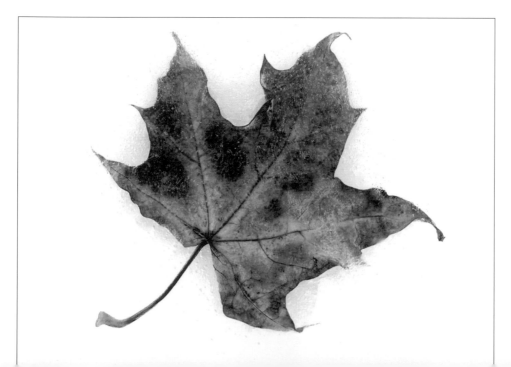

pro tip

If your flashgun wasn't supplied with a diffuser, rather than buy one, try making your own. Cut off the bottom of a semi-translucent plastic milk carton and position it over the flash head as a makeshift diffuser. You can also utilize everyday materials like tissue paper, tracing paper or a handkerchief to help soften light – use an elastic band or tape to secure it.

Diffusers

We've already touched on the one major drawback of using flash so near to the subject: it can cast hard shadows, betraying the use of artificial lighting. A reflector or second flash can be positioned to lift shadows, but there will be times when it's impractical. Instead, a diffuser will greatly help to reduce the intensity and soften shadows. There are several different types of diffuser available, made by the likes of Sto-fen Omnibounce and Lastolite, but they're all designed to do a similar job; fitting over the flash head to make the output less intense. Many modern flashes have an integral, flip-down wideangle diffusing panel, which is also well suited to macro work, and some are also supplied with a separate diffuser attachment. These are especially suitable for shooting indoors when you can bounce light off walls, ceilings or a nearby white reflective surface. It's also possible to buy a mini soft-box-type diffuser. Again, they fit to the flash head, but their larger design gives a wider and softer diffusion, greatly softening light and weakening shadows the drawback is that they can reduce the range of the flash by as much as half. However, this isn't a great problem for close-up photographers, as the automatic metering system accommodates this and the loss in range is rarely an issue.

◀ (hoverfly01.tif & hoverfly02.tif)
Using a burst of on-camera flash to capture this hoverfly created an obvious shadow around the insect and distracting reflections on its wings. I used a large diffuser for the second image (right) to produce a more natural-looking result.

Nikon D70 with 150mm lens, 1/10sec at f/14, ISO 200, tripod

Flash terminology

The world of flash photography is full of jargon, at least as much as digital photography. So here is a brief guide to the many terms that it involves.

Fill-in flash Flash is often a necessity, and in most cameras' default mode it is fired to complement rather than replace natural light. This is known as fill-in flash, and the combination of flash and ambient light should produce a realistic effect, reducing contrast in bright weather, adding punch to colours when it's gloomy, and filling-in distracting shadows. When using fill-in flash the subject needs to be static; otherwise you risk double images forming during long exposures. Depending on the combination of flash and camera you may need to apply some negative flash exposure compensation of, perhaps, −1 or −2 stops to maintain a subtle effect. The challenge is to achieve just the right amount of artificial light; too little and its effect won't be noticeable, while too much will overwhelm the natural light.

Synchronized flash The duration of a flash burst is only a matter of milliseconds, so its timing is critical. It must trigger whilst the shutter is fully open, otherwise the frame will be partially underexposed. Every camera has a maximum shutter speed at which a flash burst will expose the full area of the frame. This maximum speed is better known as the flash sync or X-sync speed and is typically upwards of 1/125sec. However, it will vary depending on the camera, as some models are faster than others. Synchronization is not an issue with some compact cameras, generally those compacts that can also record movies.

High-speed sync High-speed sync or focal-plane (FP) flash is when the unit's output is pulsed at an extremely high rate (typically 50 kHz) to simulate a continuous burst. This allows you to synchronize flash exposure with shutter speeds quicker than the normal limit of your camera. This form of flash has many uses, such as if you wish to eliminate harsh shadows caused by bright sunshine by using a burst of fill-in flash, but you also want to use a wide aperture to drop the backdrop out of focus. The wide aperture will let in more light, but you can't increase the shutter speed without exceeding the flash sync, so high-speed sync is the solution, as a faster shutter speed can be selected. The drawback is that this type of pulse reduces the flash range by as much as a third. However, close working distances mean that this isn't normally a concern. Finally, remember that, despite its name, the continuous nature of pulsing light, created by high-speed sync, is designed to simulate a long-duration flash burst. Therefore, it isn't able to freeze motion in the same way a single, powerful burst can.

Front- and rear-curtain sync Also known as first- and second-curtain sync, these offer two options for when the flash is fired while the shutter is completely open. Front-curtain sync fires the instant the shutter is fully open, freezing motion at the beginning of the exposure, and is normally the camera's default setting. However, during a lengthy exposure of a moving subject, this can leave a light trail in front of your flash-illuminated subject. In effect, this motion blur can make the subject appear to be moving backwards. The solution is to use

▲ ▲ (frontsync.tif & rearsync.tif)

To create the impression of movement, I photographed these snooker balls using a one-second exposure. The first image shows the unnatural effect of front-curtain sync, while the second shows the more natural movement captured by rear-curtain sync.

Nikon D70 with 105mm lens, one second at f/18, ISO 200, SB800 speedlight, tripod

second- or rear-curtain sync, when the flash fires just before the shutter closes, causing the light trails to follow the moving object. The drawback of rear-curtain sync is it can be difficult to compose accurately. Using front-curtain sync, the photographer is able to see the subject through the viewfinder and release the shutter at the desired moment. Front-curtain sync is best used for stationary subjects, while rear-curtain sync should be used for moving ones.

Flash fall-off The intensity of the light from a flash reduces over distance – known as 'fall-off'. This occurs because the burst of light expands as it moves further away from the flash, meaning subjects nearer the flash are better lit than their background. The rate at which the light 'falls off' can be described by using the 'inverse square law of illumination'. Light output is proportional to the inverse square of the distance (one divided by the distance, then square

pro tip

Flash compensation shouldn't be confused with exposure compensation. Exposure compensation alters the exposure for both ambient and flash light; whereas flash compensation doesn't alter how the available natural light is recorded – just the flash output.

the result). So if you double the distance you get one half squared – a quarter as much light; should you quadruple this distance, you have one quarter squared – a sixteenth as much light, because the light is now spread over a larger area. For this reason, a flash exposure can only be correct for a subject at one distance, as anything beyond this point will grow increasingly dark. Fall-off can be exaggerated further when using fast shutter speeds, as the shutter closes before anything but the subject has been illuminated; as a result, the backdrop is rendered completely black. Some objects appear more dramatic against a dark background; however, they can also look artificial. Due to the close working proximity to the subject, fall-off occurs most often when shooting close-ups.

Flash compensation and bracketing Modern flash units are sophisticated, enabling good results with little fuss. However, there will be times when you wish to adjust the output, maybe for creative reasons, or because you are faced with a very bright or dark subject. Flash compensation allows you to adjust the output either via the camera or the flash itself. Positive compensation increases the burst, making the subject appear brighter, while negative compensation reduces the output, making a subject darker or reducing unsightly highlights and reflections. Macro photographers often use negative compensation, as objects sometimes look washed out when close to the light source. However, if the subject is darker than its background, or it is highly reflective, positive compensation may be needed. One of the many advantages of shooting digitally is that you can check your results via the LCD monitor.

Flash exposure bracketing is also possible, where you can set the amount by which the flash burst is varied and take a sequence of (usually three) images with differing flash exposures.

▼ (door–3ev.tif, door–1ev.tif, door0ev.tif, door+1ev.tif & door+3ev.tif)
This peeling paint on an old garden shed door held a rustic appeal. However, it was in the shadow of an adjacent tree. When working so near to the subject negative flash compensation is often necessary to avoid bleaching out colour. Having taken several frames at different settings, I preferred the shot taken at –1Ev (second left).

Colour

Colour is everywhere, and it can be one of the most effective elements in a close-up image. Normally you are seeking to render colour as accurately as possible, most of which falls within the realm of adjusting the white balance (see page 16), or enhancing colour, which is covered by work in Photoshop (see page 156) or flash photography (page 81). However, there are times when colour itself is the theme of an image.

Colour as a subject

Have a quick look around your home and I'm sure you'll soon find a wide variety of small, brightly coloured objects. Paper clips, felt-tip pens, pencils, drinking straws, party balloons, paint and toy building blocks are just the tip of the iceberg. Having identified a suitable object, you now have to decide how you wish to arrange and light it. Small, static objects are quite simple to illuminate, and, if you wish to create an even, shadowless light, this can be done easily by creating your own makeshift light tent.

Collapsible light tents, made by the likes of Lastolite, work by surrounding the subject in white reflective material, so a burst of flash will bounce around and illuminate the subject evenly, which is great for emphasizing colour. The camera can be positioned at any point via a Velcro opening. There are also cubelite versions that work using the same principle. Just as effective, although admittedly less versatile and compact, is a large sheet of pure white card, which should be rolled and fastened so it creates a cylinder, then positioned around the subject. This works best if you're taking pictures from directly above. A carefully directed burst of flash will bounce around the reflective interior of your cylinder, creating a pleasant shadowless light, well suited to colourful close-ups. It's possible to employ a basic simple set-up like this anywhere in the house, and the cost is minimal.

pro tip

When you're searching for colourful items to snap, the brighter the better. Don't be afraid to go for bold, garish colours which clash. This will help create striking, eye-catching compositions. Try and fill the frame, so it's overflowing with bright colours. This will help maximize impact.

▲ (pencils.tif)

Often, the key to a successful still-life photo is simplicity. I arranged these pencils on a black background, then I rolled a white card cylinder to place around them.
A burst of flash bounced around the tube lit the pencils evenly.

Nikon D70 with 105mm lens, two seconds at f/16, ISO 200, SB800 speedlight, tripod

▼ (straws.tif)

I used a macro lens to photograph a box of shocking-pink drinking straws. A large aperture helped throw everything but their ends out of focus, creating a colourful repetitive pattern of shocking-pink circles.

Nikon D70 with 105mm lens, 1/20sec at f/4.5, ISO 200, tripod

▲ (lcdcover.tif)

A cross-polarized shot of the stresses in
the plastic protective covering for my
Nikon D70's LCD monitor just goes to
prove that any clear plastic object can be
totally transformed.

Canon 350D with 60mm lens, one second
at f/20, ISO 100, tripod

▶ (cdcase.tif)

Bizarre, eye-catching results are possible
by using cross-polarized light. A 60mm
macro lens allowed me to fill the frame
with surreal patterns from this CD case.
I fully polarized the light for full impact.

Canon 350D with 60mm lens, one second
at f/20, ISO 100, tripod

Cross-polarization

If you want really bright colours, try cross-polarization. This might sound rather complicated,
but it's actually very simple. The results can be stunning, with images boasting a kaleidoscope
of eye-catching colours. All you need is your digital macro set-up, a few plastic props, two
polarizing filters and a light source.

The ways in which some plastics are produced generate stresses. To the naked eye, they're
invisible, but through cross-polarized light the areas of stress become obvious, appearing as
multicoloured patterns in clear plastics. This rainbow effect is a result of diffraction of white
light into the colours of the spectrum, with the most dramatic and intense colours occurring at
the point under the most stress. Although not all plastics work well, it's possible to transform
everyday household objects, which you'd never normally consider photographing, into
striking images.

To create the cross-polarizing effect, you need to cover your light source with a polarizing filter. A lightbox is ideal for this type of photography, combined with a sheet of polarizing gel. However, this is quite a specialized material and, as a result, sheets can be costly. Instead, you could try using a second polarizing filter, although, due to their limited diameter, this will greatly restrict the type of objects you can photograph. Next, position your camera set-up directly above the item you're snapping, and perfectly parallel to it – a tripod will be essential – and select a lens, or close-up accessory, which will allow you to fill the frame. Finally, attach a polarizing filter to your lens and position your plastic object between the camera and the polarized light. Now the fun begins. Look through your camera and rotate the polarizing filter on your lens. You will see the colours alter and, depending on how far you rotate the filter, the background will either lighten or get increasingly dark. When the light is fully polarized, the background will be rendered black, and results can be dramatic. Meter with your camera's TTL system and use a remote release or self-timer function to ensure a shake-free result.

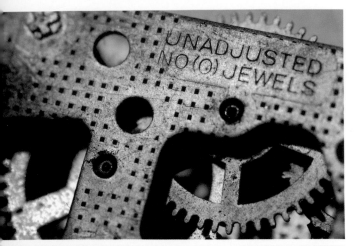

Black & white

Black & white photography is a powerful medium, especially for shooting still-lifes. Mechanisms, nuts, bolts, nails, dried flowers and cutlery are just a few items that are well suited to monochrome. Without colour contrast to enhance a picture's impact, photographers need to be more imaginative with light and composition. Strong lighting is an important ingredient, creating drama, defining shapes and emphasizing texture. The biggest challenge is imagining your subject as a series of monochromatic tones. As with all forms of still-life photography, a good imagination is vital, but photographers have a huge advantage when shooting digitally. Although many digital cameras have a custom mode to capture images in black & white, better results are possible by converting colour images. This way, it's also possible to compare the results, so you can decide which you prefer: colour or black & white? You may even like both images, and converting colour files is simple using software like Photoshop.

▲ (mechanism01.tif & mechanism02.tif)
The mechanism of an aging clock looked interesting through my macro lens.
To create a warm tone, I selected cloudy as my WB setting. I liked the result, but thought the shot would also work well in black & white. It only took a few moments to convert the file, and I was then able to compare the two images. Not being sure which I preferred, I saved and kept both.

Nikon D70 with 105mm lens, 1/2sec at f/6.3, ISO 200, tripod

▶ (forks.tif)
Strong lighting is often the key ingredient of a successful black & white shot. Without colour, a photograph has to rely on shape and form to retain the viewer's attention. With strong side lighting, even simple objects, like a fork, can be arranged to create a visually interesting composition.

Nikon D70 with 105mm lens, 1/13sec at f/2.8, ISO 200, tripod

Still-life subjects

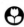

Around the house

You can find things to snap all around you, even in the comfort of your own home. In fact, I've dedicated this chapter to photographing very ordinary bits and bobs, to underline what is possible with a little ingenuity. The images in this chapter barely scratch the surface of what you can photograph; instead they're intended to help get your creative juices flowing. Practically anything can be photographed well in close-up; the possibilities are endless.

▶ (paperclips.tif)

I arranged a small number of coloured paper clips on a lightbox and positioned a sheet of white cardboard opposite the clips to bounce the flash onto the subject. This created the high-key result I was after: showing the paper clips against a brilliant white backdrop.

Nikon D70 with 105mm lens, 1/200sec at f/2.8, ISO 200, SB800 speedlight, tripod

Most light bulbs used domestically have a tungsten filament. Tungsten lighting emits more red light than ordinary daylight and has a colour temperature of around 3,200k. This can create an orange cast in pictures where tungsten is the principal light source. Depending on the subject, the results can be quite flattering, although more often it is undesirable. If your auto white balance isn't doing the trick then set the white balance to its incandescent setting, or manually to a setting of around 3,000–3,400k, and the orange cast will be corrected.

jargon busting: Tungsten lighting

Vegetables

Despite being vegetarian, even I find it difficult to get enthusiastic about snapping vegetables. Admittedly, they're not the most appealing things, but, as I keep repeating, it's not the subject matter itself but your creative approach that really counts. Subjects such as sweetcorn, peas and French beans all share a textural quality in close-up, and can be arranged to form repetitive, photogenic patterns. Slice open a red onion or pepper to reveal interesting shapes, or backlight a cabbage leaf, using a window or lightbox, to illuminate its intricate veins. However, for a more original, creative approach, why not employ your digital camera's fastest ISO sensitivity to create a grainy, moody still-life.

▼ (cabbage.tif)

I'm not a great fan of eating cabbage, but that didn't stop me placing this leaf on a lightbox to photograph. Being naturally curvy, the leaf had to be taped flat to ensure it was evenly lit.

Nikon D70 with 105mm lens, 1/20sec at f/13, ISO 200, tripod

▲ (redonion.tif)

A red onion, cut in half, revealed an attractive, interesting natural texture. I was careful to position my camera parallel with the vegetable to ensure the image remained sharp throughout.

Nikon D70 with 105mm lens, one second at f/11, ISO 200, tripod

Fruit

We've all seen still-life studies of fruit, haven't we? Often, it's nicely arranged in a basket or bowl, with soft side lighting to create mood and add depth. However, it could be argued that this approach is a little dull and has been imitated too many times; so, let's think of another approach. Instead of shooting fruit in its entirety, how about cutting it into slices and backlighting the segments. Citrus fruits, like a limes, lemons or oranges, have a particularly photogenic structure. The easiest way to backlight the segments is by using a lightbox (see page 77). Before placing the fruit on the viewing surface, it's best to protect the lightbox using a sheet or gel of translucent plastic. You don't necessarily have to use clear plastic, and bear in

▼ (lime01.tif, lime02.tif, lime03.tif & lime04.tif)
To demonstrate the effects that can be achieved by covering the light source with coloured plastic, I used different sheets of cellophane. In this instance, the subject was a thin slice of lime, but I'm sure you could think of many other objects that would work even better. Experiment, as different colours will suit different subjects.

Nikon D70 with 105mm lens, 1/8sec at f/13, ISO 200, tripod

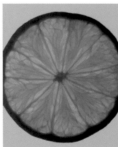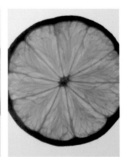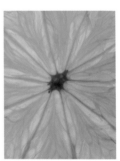

pro tip

When slicing fruit to backlight, cut the slices to approximately a quarter of an inch (or half a centimetre thick). Thicker than this and they will appear as dark silhouettes; too thin and the strength of its colour will be diminished.

mind that bright colours can totally transform backlit objects. Matched with the right subject, it's possible to produce surreal, eye-catching shots. Simply place the coloured sheet between the light source and subject, and position your camera overhead. Turn off the room lights to eliminate glare from the fruit or plastic, and experiment with different compositions. Admittedly, the brightly coloured results won't be to everyone's taste, but it is certainly a different approach to the traditional images of fruit. You could also try using the same technique for other translucent subjects, such as bubble wrap or glass.

▼ (apples.tif)

This is a more traditional approach to shooting fruit. One of the skills of still-life photography is how you arrange the subject. In my experience, it's best to keep composition simple.

Nikon D70 with 105mm lens, eight seconds at f/14, ISO 200, tripod

◀ (tomato.tif)
Using my camera's fastest ISO setting has transformed this otherwise ordinary close-up. A shallow depth of field works well, and the resulting grainy effect gives it a textural, arty quality.

Nikon D70 with 105mm lens, 1/20sec at f/4.5, ISO 1600, tripod

Although photographers are normally best advised to select their camera's slowest ISO to keep noise to a minimum and maximize image quality, a fast rating can also be used to good effect. A setting of around ISO 1600 will produce a noisy image, similar to the effects of using a high-speed film. When combined with a compatible subject, the resulting texture can prove very attractive. Arguably, it's a technique that is best reserved for still-life or black & white photography. If you wish, the effects can be further exaggerated using post-processing software. One of the joys of shooting digitally is that it's possible to experiment with different ISO sensitivities at the turn of a dial. Fruit and vegetables are just one example of the type of subjects which are well suited to this type of photography. Try to keep your arrangement simple and employ soft side light. Image noise will disguise shape and soften colour, adding an extra dimension to your shots.

▶ (sweets.tif)
Many sweets are brightly coloured, so they're well suited to close-up photography. I arranged these sherbet flying saucers in a simple pattern, used a lightbox to light them from underneath, and released the shutter.

Nikon D70 with 105mm lens, 1/40sec at f/6.3, ISO 200, tripod

(sweets.tif)

Confectionery

If you're looking for an excuse to pop out and buy something to munch on, then why not photograph confectionery. Colourful jelly beans, fruit gums and pastilles can be arranged to create bright images. Try creating patterns for interesting compositions; or place them in a repeating formation, but with one obviously missing, giving the impression it's already been eaten. Colourful boiled sweets or jelly babies are translucent enough to be backlit, or you may prefer to arrange them simply and rely on their shape to create the interest. An overhead, frame-filling shot often works well, as does selecting a low angle coupled with a shallow depth of field. Unless you want long shadows to accentuate shape and form, position a reflector or sheet of white card opposite your flash to bounce light evenly across the subject.

Glass bottles

Like many people, I'm partial to the odd drop of whisky or glass of wine, so have plenty of bottles of various shapes and colours cluttering up my shelves, and their contours, colour and design are a great subject for close-up photography. Their translucency, makes it possible to alter their appearance simply through the colour of their contents or background. I normally find window light (see page 69) sufficient for this type of photography, as flash can create ugly reflections. I often employ long shutter speeds, combined with a sturdy tripod. Obviously, glass bottles with a distinctive shape or feature are best, and antique bottles are especially suitable. Engraved writing can also make interesting shots, while altering the angle of the bottle can dramatically affect the result you achieve, adjusting the effects of depth of field and the way the light strikes the curved glass surface.

▶ (toybricks.tif)
Toy building bricks are bright, colourful and well suited to being snapped. I tried various compositions and arrangements, before deciding to leave a small gap in the bricks for interest. I settled on a horizontal composition and used a sheet of black card as the background.

Nikon D70 with 105mm lens, 1/2sec at f/8, ISO 200, tripod

◀ (whiskybottle.tif)
Before I began drinking any of its contents, I decided to grab a few close-ups of this bottle of bourbon. The engraved writing made an obvious focal point and the window light highlighted the raised edges of the lettering to create depth. The natural rich, warm colour of the whisky gives the shot its visual impact.

Nikon D70 with 105mm lens, 1/10sec at f/3.2, ISO 200, tripod

(toybricks.tif)

Toys and games

Although you'll need a good creative eye to spot the picture potential, you'll soon find that colourful building blocks, dice, a chequered chessboard, playing cards and counters can all be photographed to good effect. Again, the key is to isolate interesting detail or colour. Many toys have a recognizable shape, and for this reason can often work well in silhouette. Creating silhouettes indoors is relatively simple. You need to place the principal light source behind your subject – try using a desk lamp or even a lightbox placed on its side. Only photograph objects with interesting or bold outlines, like a chess piece or jigsaw puzzle. The strength of the image will depend on the way you position and compose the picture. If you wish to introduce colour, secure a coloured gel over the light source and remember that simple compositions are often the most striking.

If you're intending to photograph games or toys, the trick is to be imaginative with your approach. For instance, how about photographing two knights from a chess set almost nose to nose, giving the impression they're about to do battle? Or perhaps create a frame-filling shot of scrabble tiles, with a single word subtly spelt out. The best still-life shots are normally the result of the snapper having fun and enjoying their photography.

(blue.tif) (green.tif)

Close-up on / cut flowers

Although I've been intentionally trying to avoid obvious still-life subjects, I just couldn't resist including a section on shooting cut flowers. Photographing domestic blooms indoors is very different to snapping wild plants (see page 121), although the equipment required remains quite similar. Whilst in the comfort and warmth of your own living room, it's possible to influence lighting, composition and the flower's background without having to contend with outdoor elements, like wind movement. As with most indoor macro subjects, you need very little room to arrange your set-up, and a dining table can quickly be transformed into a miniature studio.

▲ ▶ (blue.tif, green.tif, pink.tif, red.tif & yellow.tif)
I positioned this gerbera in a vase next to a brightly lit window. To diffuse the natural light, I taped some tissue over the pane. I supplemented the natural light from the right by placing a reflector to the left and using a small burst of flash with −2Ev flash compensation to lift shadows and saturate the colour. I then changed the colour of the background for each frame to illustrate how the backdrop alters the appearance of a still-life shot.

Nikon D70 with 150mm lens, 1/10sec at f/4, ISO 200, SB800 speedlight, tripod

(pink.tif)

(red.tif)

(yellow.tif)

Flowers are great still-life subjects, but they vary tremendously and some are more suitable than others. Look carefully at their detail, colour, stamens and petals before deciding which to buy. Close-up photography exaggerates the tiniest imperfection; you will need pristine flowers, so ask the florist if you can select them yourself. Once you get them home, keep the stems in water, to prevent them wilting, and think about how you wish to take your pictures. An attractive vase can be a useful prop and, combined with a simple backdrop, can create a pleasant still-life image. However, macro photographers will undoubtedly feel the urge to move a little closer to isolate colourful petals or interesting stamens.

One of the best ways to highlight a flower's beauty is with frame-filling close-ups of all, or part, of it. Lighting is important. If you're taking pictures indoors, whilst relying on tungsten light, colours can be recorded with an orange cast. To avoid this, either set the white balance to incandescent or move your set-up to a brightly lit window. Personally, I prefer to combine window light, a small reflector and fill-in flash, which produces bright, natural-looking images. However, you mustn't overlook the importance of the background. Still-life photographers have the luxury of being able to alter the background, and this can prove the difference between a good and a great image. Brightly coloured subjects need complementing. Position the background further away if you are using a narrow aperture, as, ideally, it should remain a soft wash of colour. It's best to experiment with different backgrounds to achieve the best results, or you can even change the background colour on computer.

◀ ▶ (lily01.tif & lily02.tif)
I photographed the stamens of a lily, using tungsten lighting as the principal light source. The initial shot was taken using a daylight white-balance setting, and the typical warm colour cast that is associated with tungsten light is obvious. For the second image (facing page), I altered white balance to incandescent, which accurately recorded the subtle whites of the flower.

Nikon D70 with 105mm lens, 1/8sec at f/2.8, ISO 200, tripod

(lily02.tif)

When photographing flowers indoors, use a polarizing filter. This will help reduce any image-degrading reflections and will saturate colours still further. Presuming that you are using a tripod, the loss of light incurred by using the filter will not cause any problem with camera movement.

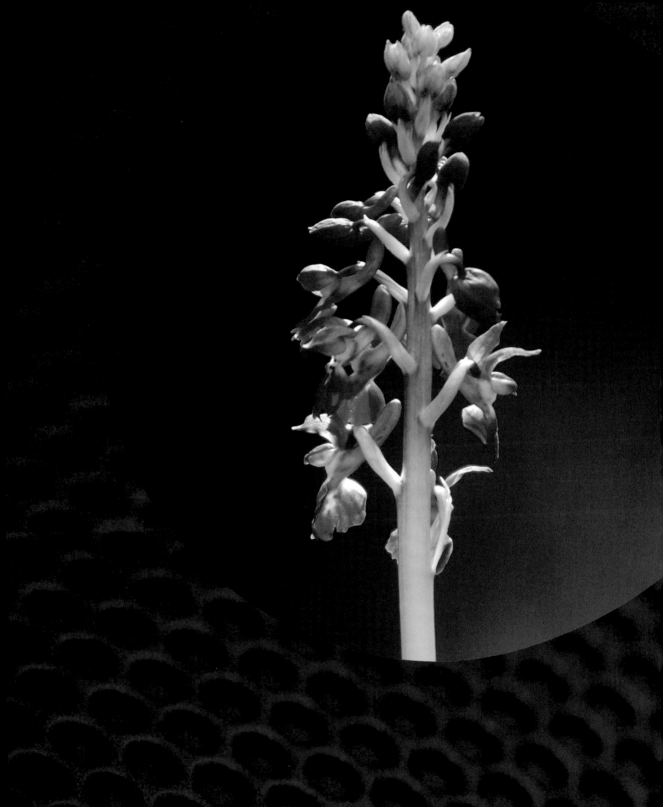

Natural-history subjects

Photographing fauna

Wildlife is unpredictable and taking macro shots can prove infuriating. However, for every moment of frustration, there'll be another of satisfaction. This section not only highlights the best photography techniques, but also offers practical advice on where to find wildlife and how it's best approached.

Butterflies

Due to their brightly coloured wings, graceful flight and general good looks, butterflies are, without question, one of the macro photographer's favourite subjects. Species vary greatly in size and appearance, with many boasting beautifully decorated wings or large 'eyespots'. If you get close enough you can distinguish the tiny iridescent scales which combine to create their vivid colours and intricate design.

Butterflies are widespread over a range of habitats; however, you can encourage them and other flying insects into your own garden by growing nectar-rich plants such as buddleia. These plants can also prove to be fantastic subjects for macro photography themselves.

Butterflies are flighty insects and are quick to react to anything they perceive as a threat, which is why snapping them can prove a challenge. You shouldn't be discouraged; good results make the frustration worthwhile. Before you begin taking pictures, identify a butterfly-rich environment such as your own garden, a local nature reserve or a butterfly farm – if you're unsure, contact your local wildlife organisation or use the Internet.

The species you photograph will depend on the time of year. Much of a butterfly's life is spent at the egg, larva or pupa stage, so they're only on the wing for a short period. They emerge to coincide with their preferred food plants, so, if you're looking to photograph a specific species, it's important to do a little research.

The obvious time to photograph butterflies is when they're at their least active. During the middle of the day, they are busy feeding and can be tricky, although not impossible, to approach. Thankfully, there is an alternative; set your alarm clock early and take pictures while they're still sleeping. Butterflies typically overnight among grasses or underneath leaves, so they can prove awkward to spot, but search carefully and you should find one. Remember to tread with caution; a careless foot can prove fatal. When you eventually find a sleeping butterfly, it may still be covered with dew and unable to fly. This will allow the use of a tripod. The only disadvantage of photographing a sleeping butterfly is that it will keep its wings closed until just before it flies. As a result, you are only able to photograph the underside.

Stalking flighty butterflies during the daytime is time-consuming, and patience is the key. Some territorial butterflies will return to the same resting place again and again. If you notice this behaviour, try waiting nearby, ready to advance. When a butterfly rests or feeds, approach slowly and with care. Be careful not to make any sudden movement or disturb surrounding vegetation. Also, be careful that your shadow is not cast over the insect.

If possible use focal lengths above 100mm to ensure a practical working distance, and, while a telezoom or medium telephoto with an extension tube will do the job for larger species, a macro lens is best.

▲ (marshfritillaries.tif)
I arrived at a local nature reserve by 6am with the intention of finding marsh fritillaries still asleep. I used a tripod and positioned the camera parallel to ensure both butterflies were in focus, while a medium aperture isolated the orchid and insects.

Nikon D70 with 105mm lens, 1/50sec at f/9, ISO 200, tripod

Try utilizing a medium aperture to isolate the insect from its surroundings whilst still achieving sufficient depth of field to keep its body and wings sharp. It should also allow, in good light, a shutter speed above 1/300sec to freeze movement and prevent camera shake. Try positioning the camera so the sensor is parallel with the subject, to maximize the available depth of field.

When a butterfly is resting with its wings open, it's natural to select a composition from above, showing the insect in its entirety and in sharp focus. However, when possible, experiment with alternative viewpoints and angles to create fresh, original images. Maybe try a shot from head-on, utilizing a large aperture to create a shallow depth of field. This way you can emphasize the butterfly's head and antennae, whilst throwing the rest of its body out of focus.

▲ (marbledwhite03.tif)

Try less-obvious viewpoints. To photograph this marbled white in the late evening light, I selected a head-on approach to emphasize its head and antennae.

Nikon D70 with 150mm lens, 1/400sec at f/4, ISO 200, handheld

Close-up on / butterflies

BUTTERFLIES ARE ONE OF THE MOST POPULAR AND ATTRACTIVE NATURAL-HISTORY SUBJECTS, BUT THEY CAN BE A CHALLENGE TO PHOTOGRAPH WELL, AND GOOD TECHNIQUE NEEDS TO BE COMBINED WITH IMAGINATION.

▶ (silverstuddedblue01.tif)

I watched this silver-studded blue flying for several minutes before it rested. It was around 8pm on a still, overcast evening, and I guessed the butterfly was ready to overnight. Initially, I tried a handheld shot using a 150mm macro lens, but I was unable to hold the camera still.

Nikon D70 with 150mm lens, 1/40sec at f/7.1, handheld

▶ (silverstuddedblue02.tif)

Being wary that the butterfly could still fly away, I gently positioned my tripod. I doubt I would have been able to do this if the insect hadn't been about to sleep. Although I used the same shutter speed, the support has eliminated shake and the image is sharp. However, I've failed to position my camera parallel to the insect.

Nikon D70 with 150mm lens, 1/40sec at f/7.1, tripod

▶ (silverstuddedblue03.tif)

I adjusted my set-up so the camera was parallel with the butterfly. To ensure the insect remained in sharp focus, I selected an aperture of f/11 for more depth of field, but this also made the grasses behind more defined and recognizable; creating a distracting background.

Nikon D70 with 150mm lens, 1/10sec at f/11, tripod

▶ (silverstuddedblue04.tif)

Now the butterfly was asleep I removed the vegetation behind with scissors: a delicate job. Care was needed to ensure none of the grasses fell towards the insect. I also moved my set-up a little nearer.

Nikon D70 with 150mm lens, 1/10sec at f/11, tripod

▶ (silverstuddedblue05.tif)

Although pleased with the previous frame, I decided to alter the background by asking my wife, who was wearing blue-denim jeans, to stand behind the insect. This isolated the butterfly against a clean, flattering tone.

Nikon D70 with 150mm lens, 1/10sec at f/11, tripod

(silverstuddedblue01.tif)

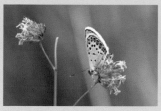
(silverstuddedblue02.tif)

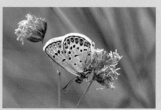
(silverstuddedblue03.tif) (silverstuddedblue04.tif)

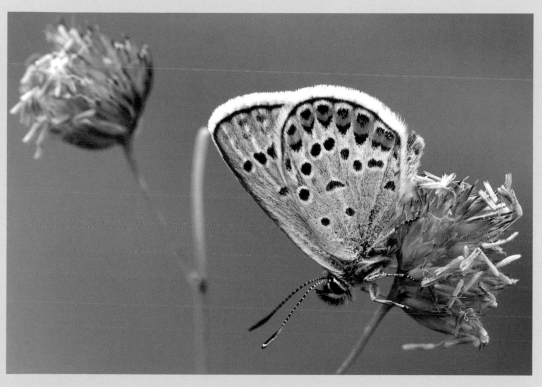
(silverstuddedblue05.tif)

Be selective, when an adult is near the end of its life, it can appear quite tatty. It may have been attacked by a bird, or lost much of its scaling and colour through age. Only photograph butterflies that remain fresh and in near-perfect condition.

pro tip

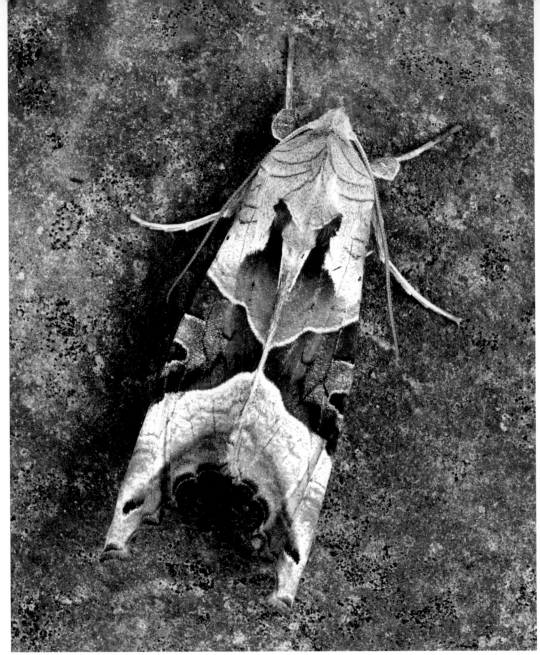

(angleshades.tif)

Moths

Compared to butterflies, many consider moths to be dull. The truth is, we're generally far less aware of the numerous types and varieties of moth, as the majority only fly at night. Many of the larger species, like those of the hawkmoth family, are in fact striking and colourful. They are good subjects to photograph, but obviously their nocturnal activity presents a problem. During the day they rest in the safety of garden hedges and undergrowth, away from the eyes of birds and predators, and, although tricky to locate, can be found if you look carefully.

◀ (angleshades.tif)

I carefully placed this moth in a plastic container and left it in the fridge for a few minutes. I then gently placed the insect on a stone and photographed it, before returning it to where it had been discovered.

Nikon D70 with 150mm lens, 1/10sec at f/20, ISO 200, tripod

Daytime is certainly best to photograph moths, as they will remain quite inactive. They normally stay stationary while you take pictures and, sometimes, can even be gently moved to a position better suited to photography. One of the reasons why moths are generally less colourful is camouflage. Some species can seemingly vanish against bark, leaves and twigs. If you find a variety such as this, rather than position the moth on a contrasting background, try placing it against a similarly coloured surface. This might contradict your instincts, but by emphasizing the camouflage you can create an intriguing shot. Be careful always to return the moth to where you found it and ensure it's safely hidden. Of course, not all moths are night-flying, and some, like the six-spot burnet and speckled yellow, feed and fly during the day. They can be approached and photographed in the same way you would a butterfly. Don't

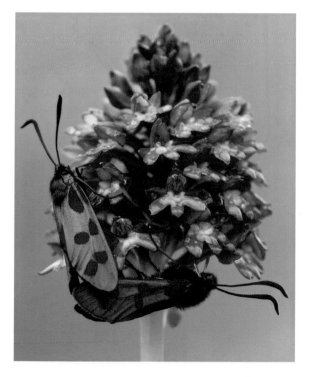

◀ (6spotburnets.tif)

This variety of moth is diurnal, but I still couldn't believe my luck when I found this mating pair on a pyramidal orchid. Before I began to take pictures, I had to carefully trim several distracting grasses from the foreground and background.

Nikon D70 with 150mm lens, 1/160sec at f/7.1, ISO 200, reflector, tripod

▶ (largereddamselfly02.tif)
I found this damselfly early one morning. I cut the reed it was resting on and placed it in a pot filled with soil. This allowed me to gently move the insect to a nearby spot where it was easier to isolate from its surroundings.

Nikon D70 with 70–300mm lens, 1/60sec at f/13, ISO 200, tripod

overlook photographing their larvae either. Many moth caterpillars are more colourful and photogenic than what they turn into. Enticed onto a suitable plant, a caterpillar will oblige by posing for pictures while it chomps through its lunch. They won't move far, as long as they have food, giving you time to try different compositions.

Breed your own Moths and butterflies begin life as tiny eggs, or ova, change to larvae, or caterpillars, and then pupa – the chrysalis stage – before finally emerging as adults. If you wish to photograph this life cycle, you can try breeding your own moths or butterflies. Eggs, larvae and pupae are available from specialist mail-order companies like the Entomological Livestock Group. They will also offer you advice on how best to care for the insects, and you can also seek advice from organizations such as the British Butterfly Conservation Society: www.butterfly-conservation.org. Although you could breed a native species, many organizations advise not releasing captive stock due to regional genetic variations and the possibility of introducing diseases. Tropical species can be safely reared, if not released, and are stunning to photograph. Most butterfly caterpillars will pupate and attach themselves to their food plant, unlike moths, which mostly burrow underground. After several days, a moth's chrysalis can be removed from the earth, although great care is needed: it's easy to damage the pupa, which could cripple the adult. Dug-up pupae should be left on slightly damp soil or moss and kept moist using a fine water spray. When they emerge, they will need twigs or netting nearby so they can climb up to dry their wings. Butterfly pupae can be delicately attached to a suitable branch, or the dowel rod of a specific emerging cage, by using the end of a matchstick to add a tiny amount of contact glue to the hard end point of the chrysalis. The time you have to wait for the adult to emerge will obviously depend on the species and the environment it's kept in. With butterflies, once you begin seeing signs of colour, from its embryonic wings under the surface of the chrysalis, you know it won't be long before it emerges. While the insect is hatching, it's at a vulnerable stage. It's unable to fly until its wings dry, so, with care, photographers are able to capture the full sequence of its emergence. Once fully hatched, the butterfly hangs upside down while it pumps fluid through the veins of its wings. The fully emerged adult will rest for an hour or two – some moth species may remain still for much longer – before taking its maiden flight; this is the best time to photograph them.

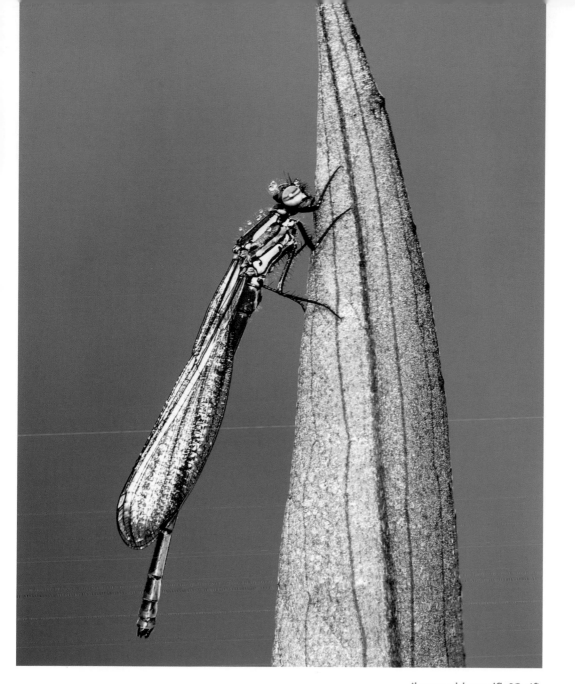

(largereddamselfly02.tif)

Dragonflies and damselflies

With brightly coloured bodies and intricate wings, dragonflies and damselflies are a great macro subject. When resting, dragonflies hold their wings open, while damselflies close their wings flat. A damselfly is also smaller, and its flight is less powerful than a dragonfly's. For the first year or two of their lives both are ugly larvae, living in ponds, reservoirs and rivers. From spring onwards, they climb from the water and emerge from their nymphal cases as adults. They remain near water, but patrol nearby hedges and fields in search of food.

When snapping insects, switch to manual focusing. Bugs are very sensitive to movement and noise, so the grind from the motor may well frighten them away. Also, if your lens isn't an internal focus (IF) design, an insect may be alarmed by the rotating front element.

Their aerial agility, powerful vision and fast reactions make them a challenging subject. Their speed in the air means they're practically impossible to photograph in flight without the aid of an elaborate, electronically triggered set-up. Instead, photographers should wait until they're resting before stalking them. Being a relatively large insect, frame-filling results can be achieved without the use of a macro lens. You could try using a telezoom with macro facility, or a short prime lens coupled with extension rings. Certainly, a longer focal length is desirable, as it allows for a greater working distance. A dragonfly's large goggle eyes are its main form of defence, and a close approach may quickly frighten them away.

Many species are fiercely territorial, and by observing their flight you should be able to identify a favourite perch. Stand nearby and wait. When your subject returns, you will be ready to slowly move into position. Selecting the right aperture is tricky: too wide and the insect won't be sharp throughout, too narrow and you risk recording the background clutter in focus. When stalking insects in this way, a tripod just isn't practical, so I opt for an aperture of around f/8 or f/11. This provides a balance between depth of field and a workable shutter speed. Traditionally, a dragonfly is best photographed from above, showing its wings outspread, or from the side to draw attention to its body, head and eyes. Whatever approach you decide upon, remember to keep your camera parallel with the subject.

It's easier to photograph dragonflies and damselflies during the early morning, before they've absorbed enough heat to be active. Damselflies will often sleep overnight on grasses or sedge near the edge of the water. You will need to search carefully, but if you find one it will probably be dew-covered and still unable to fly. Isolating the insect from its surroundings will prove tricky with so many distracting grasses nearby. Instead, using scissors, carefully cut the reed and gently embed it into a flowerpot full of damp soil. Natural-history photographers must always put the welfare of their subject first, so never move wildlife if you think you could be placing it at risk by doing so. Position your damselfly far enough away from its background so that it can be rendered pleasantly out of focus, even if you're using a small aperture to maximize depth of field. When finished, return the insect to where it was originally found.

◄ (southernhawker.tif)
I watched this hawker return to the same resting place several times. I simply waited nearby and gently moved into position when it next returned. To exclude its cluttered surroundings, I opted for a tight crop to its head and eyes.

Nikon D70 with 150mm lens, 1/320sec at f/5.6, ISO 200, handheld

While carefully searching the edges of ponds, you might just be fortunate enough to find a dragonfly or damselfly larva clinging to a grass, about to hatch. The nymphs are far smaller than you'd imagine, as, until they emerge, their wings remain folded like parachutes. While insects are emerging, they're at their most vulnerable, so great care and consideration should be taken if you wish to photograph them at this stage. A tripod and, if needed, a reflector can be carefully positioned, as the insect will remain unable to fly for an hour or two. If your camera has one, use the depth-of-field preview button to check the background and foreground for distracting elements. Although you must never move or interfere with an insect at this critical stage, with care you can use scissors to remove surrounding grasses which clutter the frame.

Check the forecast and monitor the wind speed. When snapping insects in the wild, depth of field may be just a matter of millimetres. Focusing will be critical, so avoid windy days. It can be tricky, if not impossible, to achieve sharp images while an insect is resting on a plant which is swaying.

pro tip

◀ (4spottedchaser.tif)

I was lucky to spot this nymph just as it was about to emerge. I quickly positioned my camera and tripod and carefully tidied up the background. I waited until it was almost fully emerged before pressing the shutter-release button.

Nikon D70 with 70–300mm lens, 1/60sec at f/10, ISO 200, tripod

Photographing dead insects Nature photography can be frustrating, but, in my view, the joy of making a good image is the knowledge that I'm photographing a wild creature. However, some photographers capture wild insects to freeze them or anaesthetize them so they can be photographed. In my opinion, catching an insect, placing it in a container and leaving it in a refrigerator for a short time to make it docile is just about acceptable. If the subject is removed from the wild it should be released, soon after, back into its original habitat. However, a photographer has a duty always to put the welfare of the subject first. In my view, it is unacceptable to kill a wild creature in pursuit of a picture. Even placing the ethical issues aside, where's the photographic challenge? However, should you find a dead insect you could take the opportunity to take extreme close-ups of form and detail which would otherwise be impossible to achieve.

▶ (commonfrog02.tif)

By adopting a low viewpoint and combining a 1.4x teleconverter with a telezoom lens, I've been able to make this photogenic frog stand out from its surroundings.

Nikon D70 with 100–300mm lens & 1.4x converter, 1/250sec at f/6.3, ISO 200

Frogs and toads

One of the greatest difficulties when photographing wildlife is locating the subject. However, during the breeding season, photographers can be sure that dozens, sometimes hundreds, of amphibians will be gathering in our ponds to spawn. In the warm areas frogs begin to spawn during the middle of the winter, while those in colder climes will spawn about a month later, although this obviously depends on the climate where you live. Their activity is frenzied at this time, so they will be less wary of photographers. A simple but good technique is to kneel by the water's edge and wait for one or a pair to pop their heads above water to breathe. They do this roughly every twenty minutes, so kneel by a spot where you've seen a reasonable amount of movement, and pre-focus your lens. A focal length of around 100mm is the most workable in my experience, while a polarizing filter can also be used to reduce the glare and reflection from the water, but be aware that the light will consequently be reduced by a valuable two stops.

(commonfrog02.tif)

Lizards

Apart from some of the more exotic parts of the world, the species that you are most likely to photograph will be relatively small. Reptiles are very sensitive to movement and vibration, often scuttling into cover before they have even been seen. Visit a suitable local habitat, walk slowly, look and listen carefully; lizards often give themselves away by rustling through the undergrowth. They also enjoy resting on wooden fence posts and log piles as, being cold-blooded, it's essential for them to spend a large percentage of their day basking in the sunshine – especially pregnant females. Wood creates a simple, flattering background for photography, whereas a lizard against a backdrop of, for instance, a pile of dead leaves will be lost amongst the clutter. Reptiles are at their least active in the morning when their bodies are still cold, and are less likely to hurry away when approached. If you alarm a lizard, wait silently nearby: it will almost certainly return after a short time. When photographing you should initially take a few frames from further away, so your subject grows accustomed to the noises of your camera; but ensure any beeps are turned off first. Unless you suffer from poor eyesight, always focus manually. Lizards keep completely still while they bask, and I have regularly managed to position a tripod without causing disturbance, allowing me to employ an aperture of f/14 or f/16. It is important that you do not handle lizards, as they shed their tails, an essential fat store, to fool predators.

▶ (slowworm.tif)

An overhead view might not always work, but in this instance it's highlighted the reptile's form and beauty.

Nikon D70 with 105mm lens, 1/125sec at f/13, ISO 400, handheld

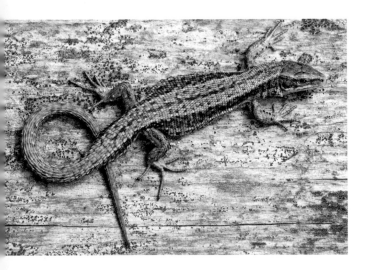

◀ (commonlizard.tif)

I noticed this pregnant female basking in sunshine on a post. Although wary, she remained still enough for me to snap away.

Nikon D70 with 150mm, 1/200sec at f/11, ISO 200

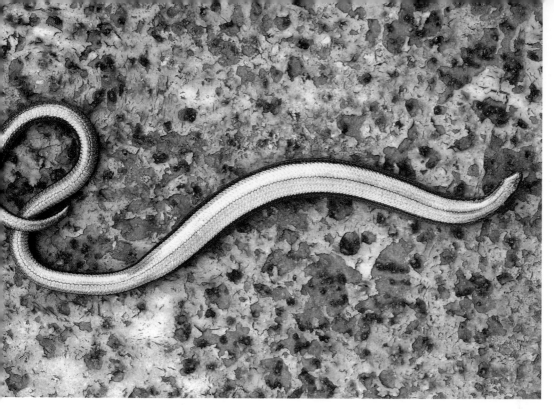

(slowworm.tif)

Slow worms

Slow worms appear snakelike, but they are, in fact, legless lizards. They favour hedgerows, heaths and grassland and feed on slugs and insects, making them popular with gardeners. They enjoy garden environments and can often be found sheltering under discarded corrugated iron sheets, rubble or wood piles. Photographers can utilize this knowledge by intentionally creating shelters to encourage slow worms into their backyard. Find an old metal sheet that you feel might also create a suitable background, and leave it in a quiet position. Being cold-blooded, lizards will remain quite inactive until they've basked in the morning sunshine. Metal and wood retain heat well, so reptiles can often be found absorbing their warmth. More so than other reptiles, slow worms will use these refuges as habitual places of shelter, and can be found underneath them in most conditions.

Because of their long, narrow shape, they don't really suit the traditional frame format when outstretched, and, like snakes, are easier to photograph when curled up. A viewpoint from directly above can produce a fresh, original composition, but this will only work if the creature's immediate surroundings also have visual impact. More often, it will be necessary to lie prone on the ground to achieve a low, eye-to-eye angle. Shooting from a low perspective often produces the most natural, flattering effect. However, due to its length, it's unlikely you'll be able to keep more than a small percentage of its body sharp, so ensure the point of focus is on its head. If the head and eyes are in soft focus, the image will be ruined. Handle slow worms with care. They are fragile reptiles and can shed their tails and thrash wildly if they feel threatened.

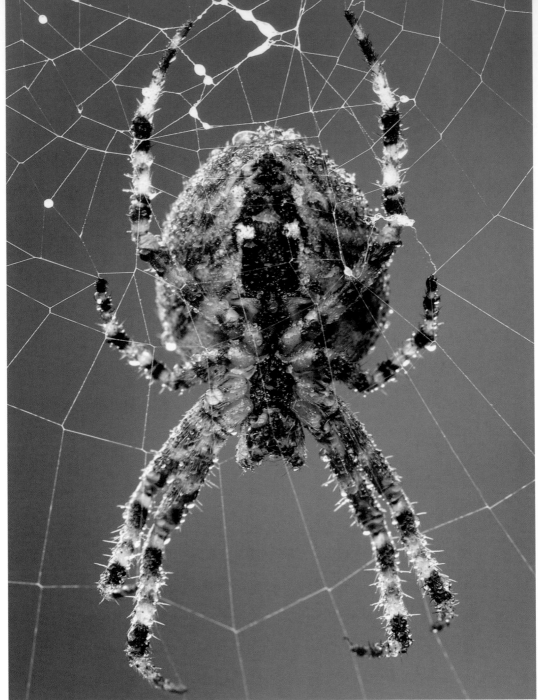

(gardenspider.tif)

Spiders

Spiders are probably the least popular creepy-crawly, but both they and their webs can make great subjects. Despite what many of us believe, not all spiders build webs. However, photographers will find it easier to find and photograph a species that does. Whilst a spider is suspended in its silk web you are able to photograph its underparts and biting mouthparts,

creating a far more striking final image. One of the most widespread species is the garden spider – it grows to a reasonable size and creates beautiful, large webs which decorate our gardens, meadows and hedgerows. Like many spiders, garden spiders are at their most noticeable during early morning, especially through autumn. Heavy dews smother their webs in water droplets, highlighting their whereabouts. To photograph spiders or webs, wait for a still day, as the slightest breeze can appear to create huge movement. You will need a tripod, but care will be needed to position it. If you jog the grasses supporting the cobweb, the droplets will fall to the ground and the vibrations will have the spider quickly scurrying away. Normally it is best to position your set-up parallel to the web, but don't overlook the possibilities of composing a shot from a slight angle, showing a side view of the insect instead. Depending on the web's position, you might even be able to select an angle from where you can silhouette the spider against the sky for a really dramatic result. For frame-filling spider shots of common species you will need a magnification between half life-size and life-size.

If you are unable to get near enough to capture the spider itself, concentrate on the web instead. Their attractive patterns are a great subject, and a standard zoom or digital compact will just about do the job. Against a clean, diffused backdrop webs look stunning, either in part or in their entirety. The thin threads of silk can disappear against their background if not enhanced by dewdrops, so if needed, this effect can be mimicked by using a spray bottle or atomizer. Simply spray the web from a short distance until you have the effect you want.

◀ (gardenspider.tif)
It might look big and scary, but in truth this garden spider was just over an inch (around 2.5cm) in length. A macro lens enabled me to fill the frame.

Nikon D70 with 150mm lens, 1/3sec at f/13, ISO 200, tripod

▶ (cobweb.tif)
Rather than shoot this web in its entirety, I isolated a small dew-laden area and positioned the camera so that grass created a pleasant green background.

Nikon D70 with 150mm, 1/50sec at f/7.1, ISO 200, tripod

Birds

While a truly wild bird won't allow you to approach close enough to capture a close-up shot, a semi-captive individual will often allow a photographer quite near. At this distance, using a focal length upwards of 300mm, it's possible to isolate the feather detail of larger birds like geese, swans and ducks. It's best to approach a bird which is already resting or asleep, although you should still tread slowly, avoiding any sudden movements. You could even try throwing down some suitable food, to entice it to remain in one position. Once close enough, slowly bring your camera to your eye and crop in tight to its body. The texture and detail of its feathers will create interesting images. Due to the focal length of the lens, depth of field will remain shallow, so select a medium aperture of f/11 or f/14. The resulting shutter speed, combined with the length and weight of using a longer lens, will require a support of some variety, and an easily manoeuvrable monopod is a handy tool.

I regularly find feathers whilst out walking, and if they're patterned and in nice condition I'll bring them home to photograph in close-up. It's easiest to record fine detail in bright, overcast light, whether outside, or indoors utilizing diffused light from a window. To maximize impact, fill the viewfinder with the feather. Another dimension is that adding some fine spray will create tiny droplets that magnify the detail and add an extra element.

▼ (pheasant.tif)
It's a sad reality that thousands of birds are killed on our roads every year. I found this dead pheasant and decided to photograph its colourful plumage.

Nikon D70 with 105mm lens, 1/4sec at f/22, ISO 200, tripod

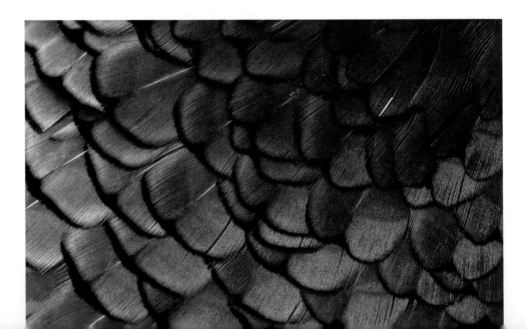

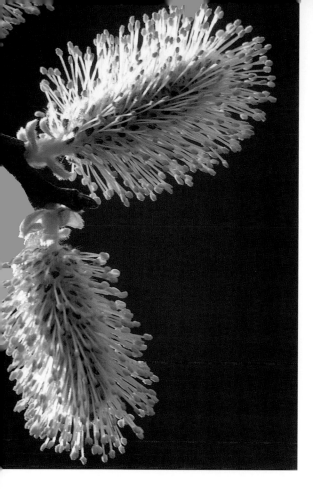

◀ (sallowcatkins.tif)
You don't necessarily need to photograph a brightly coloured flower to produce an attractive wild-plant image. These male yellow sallow catkins looked stunning in close-up, set against a contrasting dark backdrop.

Nikon D70 with 105mm lens, 1/60sec at f/11, ISO 200, tripod

Photographing flora

Wild plants give you plenty of time to compose your pictures; however, the wind provides a real challenge, as any movement is exaggerated in close-up. As well as the risk of motion blur, wind will constantly alter your composition and the plant will sway in and out of focus. The best solution is to wait for a still day. However, this isn't always possible and you can try to shield the plant instead. In the past, I've used a large sheet of cardboard, and even my camera bag, to shelter my subject, but you have to be very careful not to include your windbreak in the frame. A small clamp (see page 44), can also be used to steady a plant. Alternatively, there are normally lulls when the flower will remain perfectly still, so be patient.

Flowering and non-flowering plants vary tremendously. Each variety will need a slightly different approach, depending on their size, shape, colour and form. For this reason, it's tricky to offer general advice on how best to photograph them; there are many styles each of which will be partly dictated by the subject and your lens choice. It could be argued that pictures showing just a single flower are the most dramatic, and by using a macro lens, or extension

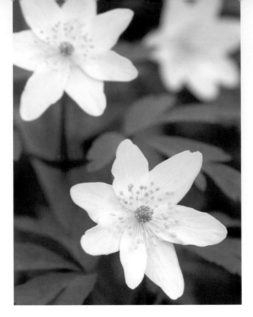

◀ (woodanenome.tif)

In direct sunlight, it would have been impossible to retain the fine detail of the white petals of these wood anemones. I selected a wide aperture, to render the two flowers behind in soft focus, and then waited for the sun to dip behind a cloud before releasing the shutter.

Nikon D70 with 150mm lens, 1/125sec at f/6.3, ISO 200, tripod

tube, photographers are able fill the frame with their subject, or part of it, maximizing visual impact. To isolate a plant from its surroundings, you should employ a longer focal length and a wide aperture. To show them in context with their surroundings, attach a wideangle lens or even try using a digital compact, with a narrower aperture.

Although it's impossible to generalize about the best light for wild-flower photography, harsh midday sun will wash out subtle colours and create distracting shadows. Instead, shoot in the early morning or late evening, when the light is softer. Backlit flowers can also create strong imagery, as the light will highlight detail. However, in my experience, it's often best to photograph plants on a bright, but overcast, day. You won't encounter glare from foliage, while colours appear stronger. Finally, when you encounter a plant you wish to photograph, move around it; consider the light and the best angle and viewpoint for photography. It could be argued that perception is as important as any technique or piece of equipment.

Whilst concentrating on composition and technique it's easy to overlook your subject's background. Remember: what you exclude from the frame is often as important as what you leave in. By simply altering your viewpoint or position slightly, you can often exclude unwanted clutter from your subject's background. When this doesn't work, you can try removing elements by hand, or 'gardening'. This is commonplace among natural-history photographers, but be careful not to harm wild plants.

jargon busting: **Gardening**

Orchids

Due to their enigmatic life cycle and striking flower spikes, orchids have long fascinated botanists, and they are an equally exciting subject for photographers. Some orchids are widespread, while others, like lady's slipper, are so scarce that they're only known to grow at one location. Orchids can be found growing in damp meadows, chalk downs, heathland, and along roadside verges; it all depends on the habitat requirements of the individual species. Many grow to a height of 1ft (20–30cm). Due to their size, a focal length upwards of 200mm is often the best choice if you wish to shoot them in their entirety. Depending on your lens's minimum focusing distance, you might need to add a small amount of extension to reduce the

▼ (heathspottedorchid.tif)
Using a tripod has enabled me to create enough depth of field while overcast light has helped record punchy, saturated colour whilst retaining good detail within the white of the flower.

Nikon D70 with 150mm lens, 1/4sec at f/14, ISO 200, tripod

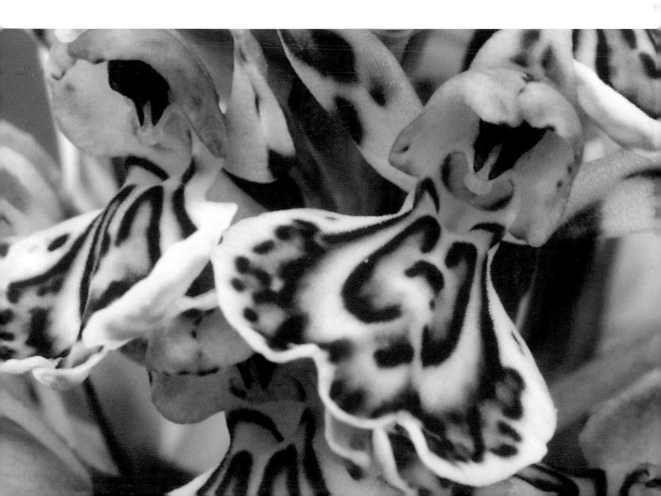

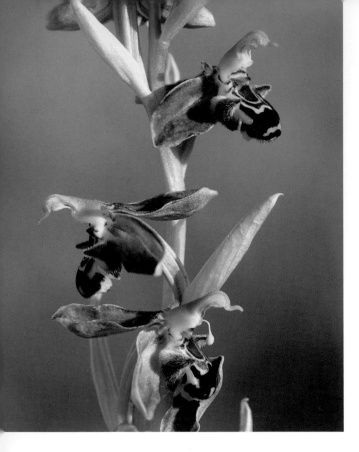

◀ (beeorchid.tif)
Due to my camera's cropped sensor, my 400mm telephoto is equivalent to 560mm on a 35mm SLR. This enabled me to achieve a frame-filling shot of this bee orchid from some distance away.

Nikon D70 with 400mm lens, 1/200sec at f/7.1, ISO 200, tripod

working distance, but a long focal length of this type will nicely isolate the flower from its surroundings. Anything but a low angle will result in an artificial look. If you find you can't position your tripod this near to the ground, use either a beanbag or a crumpled up jumper to give your camera added stability. By choosing a parallel composition, you should find an aperture of f/8–f/11 is sufficient to keep the orchid and stem in acceptable focus throughout. 'Garden' carefully around the plant to ensure nothing distracts from the flower spike itself. You may also want to try focusing through the foreground vegetation to create a pleasant green haze in the bottom third of the frame.

Like many flowers, orchids suit a vertical composition; due to their intricate form, they also warrant closer study. An orchid consists of many individual flowers. Some are three-lobed, brightly coloured and designed to aid the pollination process. Together, the individual flowers form a striking natural pattern. Try filling the viewfinder with the flower spike, remembering to select a narrow-enough aperture to create adequate depth of field. Many orchids are delicate shades of pink, mauve and purple, and bright midday sunlight will destroy these subtle tones, so use a reflector or fill-in flash to balance it. Unless I want a backlit shot, I photograph orchids in overcast light. Exposures are lengthened, but this isn't a problem as long as a support is used. Cloud is a natural diffuser, and colours will appear punchier as a result of being shot in these conditions. In fact, I sometimes cast my shadow over the subject when the natural sunlight is too harsh to record subtle colours with the accuracy I require.

Photographing fungi

Fungi are an interesting natural-history subject to photograph. They're varied, widespread and remain still, even in the strongest breeze. They vary tremendously in size and some larger species can be photographed successfully with a digital compact or basic DSLR set-up. It's not all good news, though. Fungi and toadstools have the frustrating habit of growing in the most awkward, inaccessible positions; so be prepared to get dirty in the process.

▼ (fungi01.tif)
For this shot I wanted to keep the mushrooms on the right in sharp focus, but reduce everything beyond to a gentle blur.

Nikon D70 with 105mm lens, 1/13sec at f/4.5, ISO 200, reflector, tripod

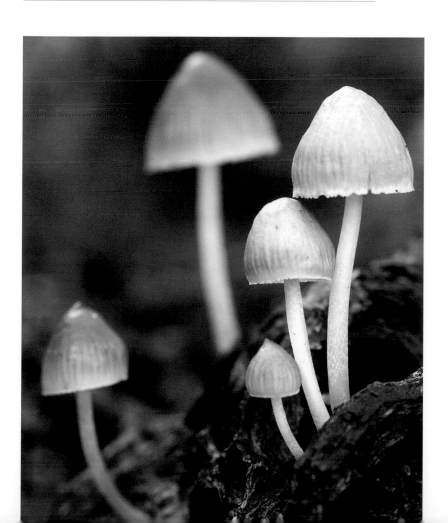

Although fungi can be found throughout the seasons, they're at their most abundant during the autumnal months, especially among birch, beech and pine trees. The damp climate encourages their growth, and a walk in your local woods should provide you with a few suitable subjects. It's best to visit on a bright, overcast day, when there's less deep shadow. Fungi can be found sprouting out of trees, stumps, fallen branches or from debris carpeting the woodland floor. Find a specimen which is in perfect condition and hasn't weathered.

Natural light is severely restricted in woodland. Combined with the small aperture you'll need to select to prioritize depth of field, shutter times are likely to be slow and will regularly exceed one or two seconds. For this reason, a tripod is essential. It's difficult to give general tips on how best to photograph fungi, as there are so many variables to consider, including type and size. A wideangle lens can be used to show the fungi in context, while low angles generally work well, especially when photographing mushrooms with attractive gills beneath the cap. If possible, try taking pictures from slightly below to exaggerate their size; a right-angle finder will prove helpful if you attempt to do this. Alternatively, you could try placing a mirror below them, angling the camera in such a way that you can photograph the reflection.

With natural light restricted by the leaf canopy, the use of artificial light is sometimes necessary. However, whenever possible, I prefer to manipulate the available natural light by using a small reflector. By using flash, you risk destroying the natural feel of the shot and the subtle colours and tints of the fungi. Also, as many species have a shiny, reflective surface, flash can create distracting 'hot spots' unless it's heavily diffused.

The law

Rare and endangered wild plants and animals are legally protected. The species covered will depend on your country, but it is illegal to take, disturb or intentionally harm any protected wild species, and in some instances a licence is required to photograph them. Nature photographers have a responsibility to be familiar with those species, so check your government's website for details.

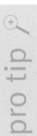

pro tip

Even using a tripod, the slight vibration created by pressing the shutter-release button can soften the resulting shot. Instead, utilize your camera's self-timer or remote release to trigger the shutter.

▲ (fungi02.tif)

I discovered these tiny mushrooms sprouting from a tree stump. I was able to position my camera from slightly below and shoot upwards, using a reflector to add light to the gills. I ended up muddy and with a stiff neck, but the result made it worthwhile.

Nikon D70 with 105mm lens, 4 seconds at f/32, ISO 200, tripod

Textures and patterns

Natural textures and patterns

Textures and patterns abound in the natural world, and while you may first look to photograph small subjects in close-up you should not overlook larger, less obvious opportunities, as the patterns you can capture can create interesting abstracts.

Bark

Bark is very tactile, and sometimes colourful, and its texture can be great for close-up shots. A visit to your local woodland will give you plenty of choice. Search for easily overlooked detail and colour, although a wider view can also produce pleasing results. Also, visit gardens or arboreta where you can find unusual species. Some barks have a smooth, glossy surface, and the resulting glare can be a problem, so try using a polarizing filter to reduce the effects. Obviously, a tree trunk is circular, and bark will curve away from the centre of your image, so employ a large depth of field if you wish to achieve a sharpness throughout – only thin trees will be affected by wind, allowing you to select a small aperture and use a tripod.

You can also employ bark as an interesting background for a host of natural subjects, including autumnal leaves, berries and nuts. If you find any fragmented pieces, they might be worth keeping to use later as a natural backdrop in the home studio, or even as a portable backdrop out in the field. However, never peel bark from living trees, as this can damage their health.

◀ (bark01.tif)
The bark on this Tibetan cherry tree seemed tatty, but a closer look revealed this layered effect. The rich shades of red looked great and a vertical composition helped create an abstract feel.

Nikon D70 with 150mm lens, 1/4sec at f/22, ISO 200, tripod

▲ (bark02.tif)

During a visit to a public garden the interesting, light-coloured bark
of a young Himalayan birch caught my eye. To avoid detail becoming
washed out, I shielded the bark, from the midday sun with my
shadow, and captured an area free from blemishes.

Nikon D70 with 150mm lens, 1/20sec at f/22, ISO 200, tripod

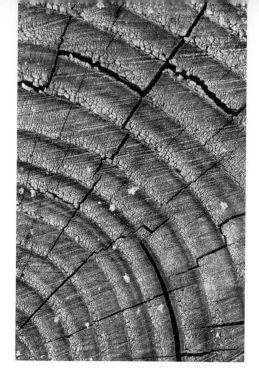

◀ (wood01.tif)

I found this weathered stump in a forestry plantation. In this instance, I positioned the middle point in the bottom-left corner to create a shot of ever increasing arcs.

Nikon D70 with 105mm lens, 1/6sec at f/14, ISO 200, tripod

Wood grain

The grain of cut wood is another texture which you might not immediately think of photographing, but weathered stumps, driftwood and even firewood can appear interesting. The rings of a cut stump form a pleasing pattern, try ignoring the normally reliable rule of thirds (see page 59) and position the centre point centrally to create a perfectly symmetrical shot. However, as always, it's worth experimenting with different viewpoints, so try placing the centre point in one of the four corners of the frame to produce a pattern that radiates from one corner. Don't forget to look for further interesting detail within the grain, such as knots or whorls, which can be placed on an intersecting third.

▶ (wood02.tif)

The trunk of a dead tree had lost its bark, exposing the wood underneath. Its weathered appearance appealed to me, and I was soon taking pictures and experimenting with different compositions.

Nikon D70 with 150mm lens, 1/8sec at f/18, ISO 200, tripod

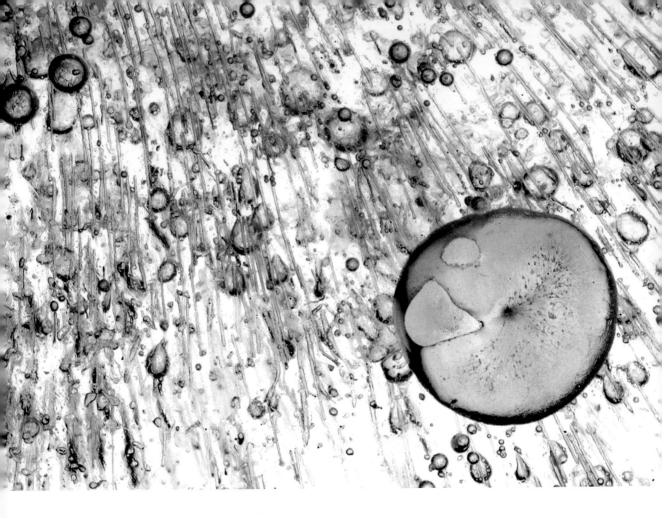

▲ (ice01.tif)

By freezing water in a lasagne dish I was able to create this interesting ice pattern. I backlit the trapped air bubbles on a lightbox and bracketed the exposure by half-stop increments.

Nikon D70 with 105mm lens, 1/4sec at f/32, ISO 200, tripod

Ice

You may think that the winter months are a good time to stay at home, practise your post-processing techniques and pack your camera away until the following spring. However, winter is an exciting time for photography and a cold spell should have you rushing outside; just wrap up warm first.

Although frost and snow can also look striking in close-up, I find the texture and form of ice most appealing. It's easy to overlook its potential, but on close inspection you will discover an

array of patterns and trapped bubbles. It's also easy to presume that ice is devoid of colour, but, when shaded, its subtle blue hues are revealed. Ice is at its most interesting after at least two or three days of cold weather. Repeated frosts will add a fresh layer of ice each day, making it thicker and less transparent. The edge of a pond or lake can be a good place to search for subjects, as you'll often find patterns caused by water ripples. However, the problem is how to position a tripod without placing one of its legs on the frozen water, a risk that you should never take. Ideally, use a tripod with centre column that can be positioned horizontally to place the camera directly overhead. Overcast light is best to photograph ice, as direct sunlight will create exposure problems and wash out subtle detail. If it's sunny, try casting your shadow across the ice you're photographing.

If you can't be tempted outdoors in the cold then try creating your own ice patterns. A large transparent, freezable dish can be filled with water and frozen at home. Try building up layers over a few days to trap more bubbles. To photograph your ice, it's best to use a lightbox to illuminate every tiny detail. Do not place the dish directly on the lightbox, but use something like a plastic envelope thickener to protect the glass. This will create an almost monochromatic shot, but, if you want to add some colour, just place a coloured plastic sheet under the ice.

▶ (ice02.tif)
A muddy puddle, just a little way up the road from where I live, was totally transformed after two days of hard frost. It being a small puddle, I could position the feet of my tripod either side without the risk of creating unsightly cracks.

Nikon D70 with 105mm lens, 1/13sec at f/13, ISO 200, tripod

The winter chill will quickly drain a camera's batteries, so, when you're not taking pictures, put the camera away in its bag. A battery which isn't working will often be OK again if you simply hold it in the warmth of your hand for a few minutes. However, it's always best to carry a spare.

pro tip

◀ (reflections.tif)

In my experience, a canal is a good spot to look for reflections. Being a narrow body of water, it's generally quite still, and there are often interesting features nearby. The colours in this shot were created by a brightly painted rowing boat.

Nikon D70 with 70–300mm lens, 1/800sec at f/10, ISO 400, tripod

Reflections

A reflection can be many things. It might be colourful ripples of water reflecting a boat or building, or maybe a night-time cityscape mirrored in a street puddle; but, while they're normally photographed in context with their surroundings, it's possible to isolate them to create striking and unusual results. A clear blue sky, or even dark rain clouds, are great for adding colour to water or glass; but avoid taking pictures when it's grey and overcast. If you're shooting water, you should also avoid windy weather, although a slight breeze can create interesting ripples. The major trouble with reflections is that they're often ephemeral, and they also alter tremendously depending on your position, so try to discover the best viewpoint.

I would also suggest you try using a focal length upwards of 300mm to isolate areas of interest, whilst also ensuring that your own reflection does not become part of the picture. If photographing rippling water, you will need a shutter speed fast enough to freeze its motion, and in my experience 1/300sec or above will do the job. Try using a polarizer to see the effect that it has on the reflection. In some situations it will enhance the reflection, as its cuts out extraneous glare; however, you should be careful that the effect does not diminish the reflection itself.

pro tip

Avoid using autofocus to shoot reflections, as they can confuse some cameras. Instead, focus manually to ensure the subject is sharp.

Lichen

Lichen is not a single organism, but a combination of two living together. The majority of lichens consist of fungal filaments, but living among the filaments are algal cells, usually from a green alga or a cyanobacterium. Lichen can prove a surprisingly good subject; through a macro lens a photographer has the ability to capture and reveal a very different world to the one we normally see. Common varieties, like yellow scales or map lichen, can be brightly coloured and create interesting patterns. Other species, like crab's eye lichen, are textured and tactile, while others form coloured 'cups' as part of their fruiting bodies.

Lichens thrive in clean air, so they're more profuse in a rural environment. Having said this, they can be found growing on bark, roof tiles and walls almost anywhere. Possibly the best place to search is an old graveyard, where mixed species sometimes grow in close proximity. Engraving on gravestones can add scale to your shot, or aid composition. As lichens grow flat, they're simple to photograph and not affected by wind, so achieving sufficient depth of field shouldn't be a problem, as long as you position your camera so that its sensor plane is parallel to the subject. Bright overcast light is best and, as you'd expect, a tripod is essential, as the best results are achieved at half life-size and larger.

▼ (lichen.tif)

Growing on the side of a rusting tractor trailer, this yellow lichen formed an attractive contrast with the peeling blue paint. Due to the long exposure, I utilized the camera's self-timer to reduce the risk of camera shake.

Nikon D70 with 105mm lens, 1 second at f/22, ISO 200, tripod

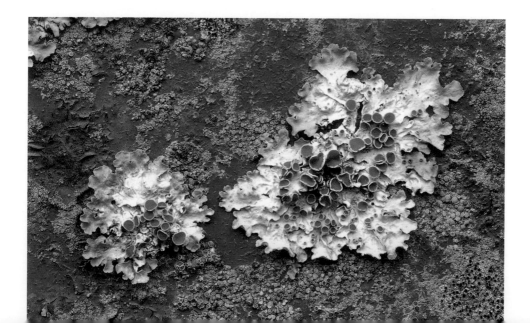

◀ (moss.tif)

Mosses enjoy growing in dark, damp environments. Light is usually limited, but on this occasion I was able to supplement the natural light simply by using a reflector.

Nikon D70 with 150mm lens, 1/3sec at f/22, ISO 200, reflector, tripod

Moss

Mosses and liverworts are tiny, non-flowering plants which grow tight to rocks, trees or the ground. As they spread, they form dense mats, creating an intricate pattern large enough for any type of digital camera to capture. They're often overlooked, as their photographic potential is only revealed when viewed close-up. In many respects, photographing moss is similar to capturing lichen. Again, the placement of your camera set-up is very important. Unless you wish deliberately to record part of your subject in soft focus for aesthetic reasons, keep your camera parallel with the subject and employ a narrow aperture. Positioning a tripod accurately isn't always easy, though. Mosses often grow in awkward places, so a versatile tripod will prove handy. Mosses require abundant water, so they grow in soggy surroundings or dark shady woodland, which can make your tripod unsteady. To combat this, try splaying the tripod's legs.

In this type of environment, natural light can be severely restricted, so you will need to employ a long exposure or use artificial lighting, like a macro flash. It's also very likely that you will need to kneel down, so carry a mat or groundsheet. Once you're in position, looking through your viewfinder will reveal a tiny jungle of fernlike foliage with intricate fronds and patterns. The colour of moss rarely varies from a shade of green. For this reason, you may feel it's necessary to boost visual interest: how about positioning a lichen-encrusted twig diagonally across the frame, or a colourful leaf, or maybe even adding water droplets?

Leaves

Leaves can be photographed in so many ways: for instance, they can be brought into a home studio, or shot outdoors in natural light. The shape and colour of a leaf varies with the species it belongs to, so there are a huge variety to capture. The appearance of a deciduous leaf changes dramatically during autumn, when chemical changes cause the leaf to alter colour. Spring is also a good time of year to photograph fresh and vibrant leaves, but they are undoubtedly at their most photogenic just before the onset of winter.

I prefer snapping leaves with strong, interesting outlines, like those of maple and oak. They can be carefully arranged in a group on the ground to create a repetitive pattern, but you can also photograph single leaves, isolating an area of colour and interest, which is most effective when backlit. I find positioning a major vein diagonally across the image greatly improves leaf close-ups. Photographing backlit leaves whilst they're still on the tree is far from easy, as any breeze will create subject movement, so it's best to pick a suitable leaf and bring it indoors where it can then be artificially backlit using a lightbox or taping it to a window.

We shouldn't forget that some plants don't actually produce leaves at all. Coniferous species, like pine, fir and spruce, produce long, sharp needles instead. Although larch is deciduous, changing colour in autumn before dropping its needles, conifers generally don't alter throughout the seasons. Compared to the colour and shape of leaves, needles certainly aren't as varied and can seem quite dull and boring. However, they still possess a natural beauty, which a macro photographer is able to reveal. The pointy needles of a conifer can look great in close-up, especially if there are tiny water droplets clinging to each spike. They're also surprisingly colourful, especially their undersides. If you visit a local forestry plantation, you'll often find cut branches discarded by the edge of the footpath. Carefully laid flat on top of one another, the needles form a pleasing natural texture, which can then be easily photographed.

◀ (backlitleaves.tif)

Photographing backlit leaves is tricky whilst they're attached to the tree, but the long, spiky leaves of this montbretia plant were too rigid and near to the ground to be effected by wind. The shadows from the overlapping leaves add more depth to the shot.

Nikon D70 with 70–300mm lens, 1/50sec at f/18, ISO 200, tripod

Close-up on / leaves

LEAVES CAN LOOK SPECTACULAR WHEN BACKLIT, BUT TO MAKE THIS PRACTICAL YOU NEED TO SELECT AN APPROPRIATE SPECIMEN AND USE A LIGHTBOX OR A BRIGHTLY LIT WINDOW.

▶ (leaf01.tif)

I found this brightly coloured maple leaf and, using tape, stretched it flat against my south-facing living-room window.

The afternoon sunlight backlit my leaf, creating the same effect as if it were on a lightbox. Also, being secured to a vertical surface made it easier for me to position my tripod.

▶ (leaf02.tif)

Having tried a vertical composition I decided a horizontal one worked best, but not filling the entire frame with the leaf weakened the shot.

Nikon D70 with 105mm lens, 1/6sec at f/22, ISO 200, tripod

▶ (leaf03.tif)

To eliminate the gaps, I moved my set-up nearer, keeping the sensor plane parallel to the leaf. I was careful to isolate a section of the leaf which was colourful, but felt the position of the major veins divided the frame up into too many segments.

Nikon D70 with 105mm lens, 1/6sec at f/22, ISO 200, tripod

▶ (leaf04.tif)

By just altering the camera's position slightly to the left, I altered the dynamics of the shot. I positioned the major vein so it cut diagonally across the image, creating a simpler and more pleasing composition. As a result of using a small aperture, my shutter speed was slow. So I employed the camera's self-timer to minimize camera shake.

Nikon D70 with 105mm lens, 1/6sec at f/22, ISO 200, tripod

(leaf01.tif) (leaf02.tif) (leaf03.tif)

(leaf04.tif)

Nuts and berries

Although you could photograph nuts or berries bought from a shop, it's a lot more fun to gather autumn fruits from the wild. Chestnuts, acorns and blackberries are among the most photogenic. Arranged in a small container so there are no distracting gaps, they form an effective repeated texture. To add further depth to your shot, try adding fine water droplets, taking a few frames first in case it doesn't improve the shot. Then, if you don't like the effect, you needn't waste time drying your subject.

▼ (acorns.tif)

It only took a few minutes to gather a handful of acorns from a local wood. Arranged together they formed a pleasing pattern, and, having taken a few frames, I used an atomizer to add some water droplets.

Nikon D70 with 105mm lens, 1/8sec at f/20, ISO 200, tripod

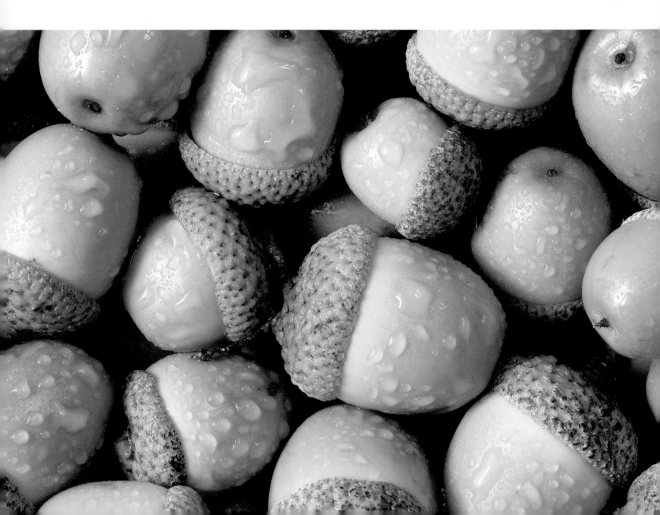

▲ (pebbles.tif)

I liked the contrast between the wet stones and the drier ones, and using the long end of a standard zoom I took this frame from overhead in overcast light.

Nikon D70 with 18–70mm, 1/30sec at f/11, ISO 200, tripod

▲ (sand.tif)

Each time you visit the beach you'll discover very different patterns in the sand. They're best photographed in the evening sunlight, which emphasizes form.

Nikon D70 with 18–70mm lens, 1/40sec at f/18, ISO 200, tripod

Seaside

Living by the sea in Cornwall, England, I'm luckier than most. The nearest beach is just a short drive away, and I often visit with my camera in search of natural textures. Collections of stones and pebbles, as well as patterns in the sand or rock, can form interesting shots. They're best shot in either morning or evening light, when the sun is casting long shadows that emphasize the texture, although overcast days can help suppress excessive contrast. Try using a medium telephoto lens from some distance, as not only will this compress perspective, but you'll find the extra working distance useful to ensure your own shadow does not appear in the frame. It's also worth using a polarizing filter to reduce glare from wet sand. Most seaside subjects are easy to photograph with any type of digital camera and still achieve frame-filling results, so a digital compact will be every bit as effective as a DSLR.

Molluscs and crustaceans, such as mussels, whelks, limpets and barnacles, attach to rocky outcrops and can be found in large communities. Together they form an unusual repetitive pattern. Fill the viewfinder to maximize impact and avoid harsh light. Seaweed is another photogenic subject which you could be forgiven for overlooking. The air bladders and spongy reproductive bodies of widespread species like egg, spiral and bladder wrack, look intriguing in close-up. They're best photographed when wet, so check the tide times and catch them when the water's receding. Positioning a tripod can be fiddly, but the struggle will be worthwhile. Seaweed being reflective, you may need to use a polarizing filter to reduce glare.

Clambering around on uneven, slippery rocks, carrying expensive camera equipment can be a recipe for disaster. Tread with care and always wear supportive footwear. Also, remember to check the tide times before you visit. The seaside can be a dangerous place, and for your own safety it's important you know if the tide is on its way in or out. Also, don't wander far from your equipment. I know a photographer who became so engrossed in picture taking that, when he went to change lens, he found his camera bag was floating out to sea.

If you're unable to visit the beach, why not buy a bag of seashells. Try arranging a group into a pattern, or isolate the colour and detail of a single shell. Try photographing your arrangement indoors under window light.

◄ (rock.tif)
Erosion, caused by crashing waves, has revealed this wonderful textured surface. I used a 105mm macro lens to photograph the flaking, multicoloured rock. Bright overcast light proved best to capture the subtle pastel shades.

Nikon D70 with 105mm lens, 1/30 at f/16, ISO 200, tripod

pro tip

Sand can be very damaging to cameras and lenses. Be careful if changing a lens and gently clean your gear with a soft cloth when you get home. Also, salt water will erode the joints and springs of your tripod, so clean it well.

► (barnacles.tif)

The variety of seaside textures is astounding, and it's a great place to hone your close-up skills. Here a barnacle-encrusted boulder caught my eye; I included a single limpet to add scale.

Nikon D70 with 150mm lens, 1/20sec at f/16, ISO 100, tripod

▼ (seaweed.tif)

Normally, I'd use a polarizing filter to reduce reflections from the seaweed's surface, but on this occasion I liked the effect.

Nikon D70 with 150mm lens, 1/6sec at f/11, ISO 200, tripod

Water

You've already seen how tiny water particles can transform the appearance of a main subject, but combined with a suitable background they can provide a great subject themselves. Water droplets form well on shiny surfaces like plastics and metals. Add the water patiently using a dropper or atomizer, or let nature do the hard work for you; you can photograph any suitable surface after a fine mist or overnight dew.

To maximize depth of field, it's normally best to keep the camera's sensor plane parallel with the subject. However, when shooting water, there's a catch: water gathered on a flat surface, can capture a reflection of you in each droplet. Using a longer lens with a close-up attachment will alleviate this, but you should position your camera at an angle to minimize your reflection, and remember to select a small aperture to compensate for not being parallel with the subject.

▼ (water.tif)

This shot happened by accident. I'd left a broken pedal bin outside to throw away. It rained overnight and striking irregular droplets of water formed on the brushed metal surface.

Nikon D70 with 150mm lens, 1/6sec at f/10, ISO 200, tripod

▶ (raindrops.tif)

I was documenting a day in the life of a postman when I took this shot of the droplets of water formed on my porch window, with the postman's brightly coloured jacket for the background.

Nikon D70 with 105mm lens, 1/60sec at f/4.5, ISO 250, tripod

(raindrops.tif)

Water can quickly evaporate and alter in appearance, which can prove frustrating. To create more permanent droplets, try using glycerine or a water/glycerine mixture, and position it using a dropper.

(computer.tif)

Synthetic textures and patterns

It isn't just the natural world that offers fantastic macro opportunities. There are a myriad of artificial textures and patterns that you can photograph both inside and outside your home.

Electrical items

If you have a broken computer or know of a friend or neighbour throwing one out, have a quick look inside. You can find patterns in the most unlikely places, and the internal workings can look striking in close-up. Remove the parts you wish to photograph and place them flat on a work surface. Likewise a host of other electrical items can provide fascinating patterns both inside and out. Before moving your tripod into position, look through your viewfinder to explore the subject handheld. With a rough idea of what you wish to capture, attach the camera to your support and then fine-tune your composition. Natural light from a window should prove adequate, or else try using a macro flash. Alternatively, position a couple of desk lamps nearby, and direct the light as you require.

◄ (speakergrill.tif)

The grill, protecting the speaker of a portable CD player, is typical of the patterns you can find around your home. I deliberately placed my camera at a slight angle to the speaker and employed a medium aperture to render much of the grill in soft focus. I felt this produced a more striking effect.

Nikon D70 with 105mm lens, 1/60sec at f/11, ISO 200, tripod

◄ (computer.tif)

Before we threw out a broken PC, I decided to search for something to photograph. The circuitry of this motherboard forms a bizarre pattern.

Nikon D70 with 105mm lens, f/2.5sec at f/8, ISO 200, tripod

► (television.tif)

Even the casing of my TV justifies a frame or two. I positioned my camera so the lines cut diagonally across the image, to create a striking result.

Nikon D70 with 150mm lens, 1/100sec at f/2.8, ISO 200, tripod

Rust

Rust is yet another everyday subject that close-up photographers can transform into art. If you have a garden shed, you may very well have an old metal sheet, can, bicycle or maybe some garden machinery slowly rusting. I live next door to a smallholding, so there's no shortage of rusting machinery scattered about the farmyard. Like many of the subjects found within this chapter, rust is a good example of how we're able to reveal often overlooked textural qualities. The trick is finding, and then isolating, an area of rust with colour or interest. Rust eating away at a painted surface normally produces the most striking results, although often it's the shape and form of the rusted object which will dictate the shot's appeal and interest. For instance, a rusting chain, bike wheel or car grill will create a far more interesting shot than simply a flat rusted surface. Strong side lighting can produce a more dramatic result, as can a shallow depth of field.

▼ (tractorgrill.tif)
Although there is little colour in this shot, the holes in the rusting grill of an old tractor created the aesthetic interest. To emphasize the curve of the metal, I positioned my camera so it cut diagonally across the frame and utilized my lens's fastest aperture.

Nikon D70 with 105mm lens, 1/60sec at f/2.8, ISO 200, tripod

▼ (chain.tif)
The rusting links, of a huge chain near a lock-gate, formed a pleasing pattern. Once I'd identified its potential, the rest was simple. I positioned my tripod opposite, and, with my camera parallel, zoomed in tight until I'd framed the shot the way I wanted.

Nikon D70 with 18–70mm lens, 1/15sec at f/13, ISO 200, tripod

▲ (napkin.tif)

My wife wasn't too impressed when I started dismantling her nicely set dinner table, just so I could photograph the end of this rolled-up napkin. Luckily for me, I managed to grab the shot before our guests arrived.

Nikon D70 with 105mm lens, 1/30sec at f/4, ISO 200, tripod

Fabrics

Often texture can't be appreciated from a distance. In its entirety, the potential of, say, a woolly jumper, curtains or embroidery might not be glaringly obvious. However, through a close-up attachment, intricate form, colour and detail are revealed. Have a quick look around your home or even your wardrobe. Things like denim jeans, embroidered cushions, knitted jumpers, a ball of wool, even a napkin can be photographed to good effect. The repetitive form of a fabric weave can look especially interesting in close-up. A shallow depth of field can work well, with everything but the point of focus drifting gently into soft focus. Moiré (see page 22) can sometimes be a problem because of the fine, repeating patterns of a fabric. If this is apparent then try taking the shot from a slightly different angle or distance.

Post-camera processing

The picture-taking process doesn't end when you press the shutter-release button; like film processing and development, digital files need attention before they are complete. Once your files have been downloaded the shots need to be individually assessed, edited and deleted where applicable. Then the files require a degree of post-processing, either using the software supplied with the camera or a third-party imaging program.

There is a huge difference between enhancing an image, to ensure it accurately resembles what you saw through the viewfinder, and radically altering it. I'm a great believer that the skill of creating a good image should be achieved in-camera. So this chapter concentrates on bringing the best out of your images, not manufacturing false ones.

Without doubt, the most widely used imaging software is Adobe Photoshop. It's a sophisticated program, capable of almost any result, and while the full version is expensive most enthusiasts rely on the cut-down Photoshop Elements. Although it doesn't boast the facilities of the full version, it still possesses the most useful tools.

◀ (toolpalette.tif)
The basic tools for Photoshop can be found in the tool palette.

Plug-ins are additional features, produced by a third party, which programs like Photoshop can support to increase their capabilities.

jargon busting: **Plug-ins**

had the shooting parameters applied, making it more flexible. If you shoot
Jpegs then you can download your images and get straight down to business
in Photoshop, however, raw files require a little time spent converting them first.

(rawconversion01.tif)

◀ (rawconversion01.tif)
Once your images are downloaded they will normally be
displayed in the software bundled with your camera. You now
need to decide exactly which images justify your time and
attention. Technically poor shots should be deleted as there's no
point keeping them, and unless similar images show different
aspects you should normally only keep the best. It's best to view
raw files full screen, allowing you to assess each individually. It's
also a good idea to enlarge them to 100% to check sharpness,
especially when comparing similar images. Personally, I view all
raw files a couple of times before deciding which ones I should
process. I then open the files in the program's 'Editor'.

(rawconversion02.tif)

◀ (rawconversion02.tif)
Depending on the software you're using, a tool palette of some
description will appear, allowing shooting parameters, such as
white balance, to be adjusted via sliders, showing live previews in
the best programs. I normally make a few changes, but prefer to
alter tonal range and saturation in Photoshop. Finally, save the
image. Usually, uncompressed tiffs are the best option, as they
retain all of the information.

pro tip

When saving a tiff you will be given the option of an 8-bit file or a 16-bit file.
If you intend to do further image-processing in Photoshop, save the shot as
a 16-bit file to maximize image quality. It can can later be resaved in 8-bit
format, to keep the image at a more manageable file size.

At some point, you will need to increase the size of a digital image or change its resolution. This might be for the purpose of entering a photo competition, submitting the photo to an agency or simply because you wish to produce a large print. There are two ways of doing this: resizing and resampling.

▶ (resizing01.tif)
You can resize a digital photo by opening the image-size dialogue box by clicking (Image>Image size); ensure the resample image box is not ticked and enter values for width, height or resolution. Resizing an image adjusts the size without altering the total pixel dimensions. When the resolution is increased, the print size becomes smaller, while making an image larger will mean that its resolution decreases. In contrast, resampling a picture relies on a method called interpolation, which creates or deletes pixels to alter the pixel dimensions. Click (Image>Image size) to open the image-size dialogue box, but this time check the resample image box. You can now alter the image dimensions by entering new values. Ensure the constrain proportions box is also ticked, so that when you change one dimension, the other will be automatically adjusted. The existing pixels are interpolated using algorithms to create new pixels. By adding more pixels via interpolation, print resolution can be maintained; however, image quality is compromised. The three main methods of interpolation are bicubic, bilinear and nearest neighbour. Nearest neighbour doesn't really interpolate a digital image, but works by simply mimicking the value of the adjacent pixel – results are rarely acceptable and it's best avoided. Bicubic is better than bilinear for estimating new pixel values, but is also the slowest of the three processes.

(resizing01.tif)

▶ (resizing02.tif)
If you wish to substantially enlarge a picture's resolution, but wish to avoid degrading image quality, it's best to invest in specialist interpolation software. I use Genuine Fractals, the industry's most widely accepted interpolation program.

(resizing02.tif)

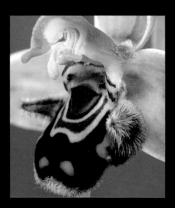

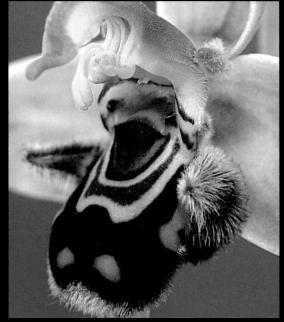

(resizingbefore.tif) (resizingafter.tif)

Interpolation will naturally exaggerate poor image quality and noise. For this same reason, it's important that you do not sharpen an image before interpolation, as it will appear more jagged.

There are times when a digital image can be strengthened through selective cropping, such as when the composition appears unbalanced, or when you wish to remove something from the edge of the frame. Cropping can transform an image, but be aware that you are reducing the picture's dimensions.

When I photographed this chaser dragonfly I'd included a distracting grass near the bottom of the frame that needed removing.

► (cropping01.tif)
1: Open the image and select the crop tool from the toolbar.

► (cropping02.tif)
2: Hold down the click and drag the cursor to highlight the area of the picture you wish to keep. The part that will be cropped away is shaded.

3: If necessary, make fine adjustments to the crop parameters by using the selection points.

► (cropping03.tif)
4: Once satisfied with the final composition, complete the crop by choosing Image>Crop or double clicking within the cropped area of the image.

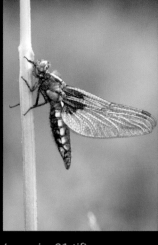

(cropping01.tif)

(cropping02.tif)

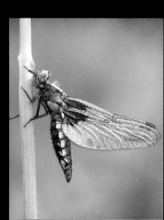

Adjusting tonal range with levels and curves

Ideally, a digital image should boast a full range of tones, and often the tonal range needs tweaking. This can be done simply via three tools you can use to adjust brightness and contrast in Photoshop: levels, curves, or brightness & contrast. The latter (Image>Adjust>Brightness/Contrast) is the most straightforward of the three methods, but it doesn't allow photographers to alter contrast with much precision so it is best to use levels or curves.

Levels

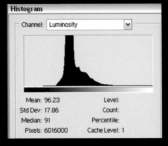

(levels01.tif)

This original shot of water droplets clinging to the needles of a pine lacked impact, so I decided to use levels to improve its tonal range.

◀ (levels01.tif)
1: First, open the image and then review its histogram (Image>Histogram).

(levels02.tif)

◀ (levels02.tif)
2: Close the histogram and open the levels dialogue box (Image>Adjust>Levels). A new histogram will appear within the box, with three pointers underneath its left, right and centre. By moving the arrows you can 'stretch' the tonal range, so that the darkest areas of the photograph become black and the lightest become white.

pro tip

There is an auto button on the right of the levels dialogue box that adjusts them automatically, but rarely produces a satisfactory result.

▶ (levels03.tif)

3: Ensure that the preview button is checked and then slide the right-hand (clear/white) pointer to the left to lighten the image.

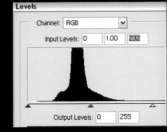

▶ (levels04.tif)

4: Now, slide the left (black) arrow to the right. You will notice the image visibly darken.

5: The central (grey) arrow represents mid-tone, and by sliding the pointer left or right it's possible to lighten or darken the tonal mid-range without significantly altering highlights and shadows.

(levels03.tif)

▼ (levelsbefore.tif & levelsafter.tif)

6: The amount of adjustment you need to make depends on the original photo and the effect you desire. Be careful not to exaggerate contrast too much, and experiment until you feel confident, comparing results as you go along.

(levels04.tif)

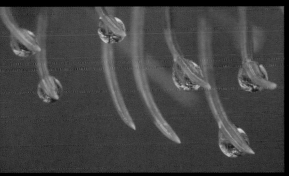

(levelsbefore.tif)

(levelsafter.tif)

Curves

Although I prefer the simplicity of levels, an image's contrast can also be adjusted using curves. Whilst levels appears as a histogram, curves takes the form of a grid, with a line running from the bottom-left to the top-right. The principle remains similar to that of levels: the bottom left represents the shadow area, top right is highlights and the mid-point mid-tones. By clicking and dragging the line into different positions you can alter the tonal range more specifically than in levels.

(saturation01.tif)

Saturation

Photographers often strive to achieve pictures with saturated colours. Although it's important to keep pictures looking natural, a picture boasting strong colours will often create a more striking result.

(saturation02.tif)

◄ (saturation01.tif)
1: Open your image and then choose (Image>Adjust> Hue/Saturation) to open the saturation dialogue box.

◄ (saturation02.tif)
2: By dragging the saturation slider to the right, the intensity of the colours will be increased. However, if saturation is increased much beyond +30, colours will begin to look artificial. If you drag the slider to the far left, the shot will become monochromatic.

(saturation03.tif)

◄ (saturation03.tif)
3: It's also possible to select specific colours from the Edit drop-down list. This can be utilized to make fine adjustments to unsightly colour casts.

▼ (saturationbefore.tif & saturationafter.tif)
4: The final result has far more impact and can be enhanced further by adjusting the tonal range in levels or curves.

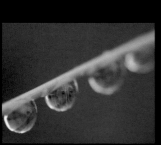

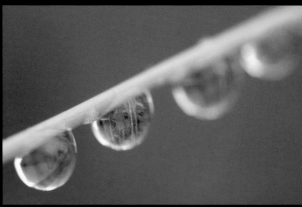

(saturationbefore.tif) (saturationafter.tif)

Regardless of how meticulously you care for your camera, dirt and dust will often appear as dark specks in your images. This is one of the few disadvantages of shooting digitally, and digital files often need tidying up before they can be printed. This can be done quickly and easily using the clone tool.

After several days of heavy use, my camera's sensor had attracted some nasty particles of dust. Using the clone tool, I spent a few moments tidying this image.

(cloning01.tif)

▶ (cloning01.tif)
1: Open the image and zoom in to 100% on the area which requires cleaning. Alternatively, you can enlarge the file until you can distinguish individual pixels.

▶ (cloning02.tif)
2: Select the clone tool from the toolbar.

(cloning02.tif)

As useful as the clone tool might be, it still has its shortcomings. For instance, if you're trying to clone from an area with more complex texture or colours, you can end up with obvious blotches. In situations like this, use the Healing Brush (only available on later versions of Photoshop) in the same way as the clone tool, and it will blend the repair into the background.

jargon busting: Healing Brush

(cloning03.tif)

◄ (cloning03.tif)

3: From the drop-down menu, select a suitable brush size and style. A hard-edged brush suits areas of single tone, while a soft-edged brush is better for areas of detail. For dust spots try using a small, soft brush of around 30 pixels.

(cloning04.tif)

◄ (cloning04.tif)

4: To define the region to clone from, hover the cursor over a suitable area adjacent to the dust mark and press the Alt key, whilst clicking your mouse simultaneously. This is called the 'source point' and should be similar in colour and texture.

(cloning05.tif)

◄ (cloning05.tif)

5: Finally, reposition the cursor over the area needing to be cloned and click your mouse, replacing the speck with the clean area you selected.

▼ (cloningbefore.tif & cloning after.tif)

6: Repeat this process until all blemishes are removed.

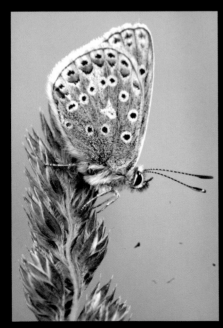

(cloningbefore.tif) (cloningafter.tif)

Panoramic images have become increasingly popular, however, you rarely see panoramic close-ups. Digital shots can be stitched together in Photoshop, or in a specialist program which will offer more sophisticated controls. Although it won't suit all close-up subjects, digital close-up photographers shouldn't overlook the potential of panoramas.

(stitching01.tif)

► (stitching01.tif)
1: Select and open the images you wish to stitch together.

► (stitching02.tif)
2: Create a new blank file (File>New) to hold the stitched panel. Set the background to white and select the resolution you require, normally 300dpi. Type in the dimensions you desire. This will depend on the size and number of shots you're stitching – in this instance, my images were 3008x2000pixels, so I selected a width twice this (6016x2000) and clicked OK.

(stitching02.tif)

► (stitching03.tif)
3: Using the move tool, drag each picture into your new file. Each file will become a layer. Roughly overlap one shot over the other and then click View>Actual pixels. It's easiest now to use the arrow keys to nudge pictures into place. Utilize key areas of detail to ensure you position the shots perfectly.

(stitching03.tif)

It would take a full chapter to explain the ways in which layers can be used. By placing two or more layers on top of one another it's possible to create complex images, add text, or blend images together. Each layer can be altered, its opacity adjusted, drawn on and moved around independently to create whatever result you wish.

jargon busting: Layers

When taking the original pictures be sure to include an overlap with the previous shot of about 20–30%. This might seem wasteful, but you'll need the margin when lining up the frames. Also, keep your exposure and white balance identical for each frame.

(stitching04.tif)

(stitching05.tif)

◀ (stitching04.tif)

4: No matter how careful you were when shooting, parts of the overlapping frames won't quite align. Use the Eraser to make the transition, to remove parts of the top layer and help blend the images together.

◀ (stitching05.tif)

5: Zooming out will show the effectiveness of using the eraser. Now merge the layers (Layer>Merge down). By doing this, you can now use the clone tool to tidy up any detail which still doesn't quite match, and the crop tool to eliminate any unwanted overlap.

▼ (stitching06.tif)

6: Finally, adjust the image using levels or curves (see page 156), and sharpen.

(stitching06.tif)

Digital cameras are designed with a low-pass/anti-alias filter in front of the image-sensor to combat the effects of moiré (see page 22). This softens the image, and while it is resharpened in camera it is one reason why some images, particularly raw files, need sharpening post-capture. Sharpening increases the edge contrast; it doesn't actually make images sharper it only makes them appear sharper, so you cannot use sharpening to improve an out-of-focus shot, and over-sharpening will result in ugly halos appearing around edges.

Sharpening an image should be your very last action, so only apply it once you have completed your other alterations. Photoshop has several sharpening filters, including Sharpen, Sharpen Edges, and Sharpen More. Although they work, the user has no real control, so I use Unsharp Mask (USM). However, if you intend to submit images to an agency, note that many only accept unsharpened images, preferring to leave sharpening to their clients.

► (sharpening01.tif)
1: Open Unsharp Mask (Filter>Sharpen>Unsharp Mask). The USM dialogue box will appear. Ensure the Preview box is checked.

► (sharpening02.tif)
2: You can control the parameters by adjusting the three sliders. Amount controls the intensity of the sharpening effect; this can vary from 1 to 500%.

3: By determining the number of pixels that sharpening will affect, the Radius slider will make edges appear more contrasty. For high-resolution images, it's best to select a Radius no greater than 2.

4: The Threshold slider controls where Photoshop applies the USM, based on variations in tone. A Threshold of zero applies the USM filter to every edge, where one of five would mean two tones must be more than five levels apart (out of 256) before USM is applied.

(sharpening01.tif)

(sharpening02.tif)

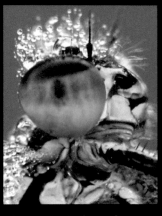

◀ (sharpeningbefore.tif)
Enlarged section before USM.

◀ (sharpeningafter.tif)
Enlarged section after USM.

(sharpeningbefore.tif)

(sharpeningafter.tif)

pro tip

The best way to learn is to experiment. Adjust each slider until you grow familiar with its effects. Each shot needs a different amount of USM, but I've found that the following settings generally work well for large digital files of 17 megabytes and above: amount =80–120%, radius = 1 or 2, threshold = 0 or 1

As mentioned at the beginning of this tutorial, sharpening doesn't actually create an image that is more in-focus, it simply creates the appearance of a sharper image. This is done by increasing the edge contrast, if this process is taken too far then sharpening halos can appear. These occur when the edge contrast has been increased to such an extent that the light side of the boundary is noticeably lighter than the rest of the light area. This gives the appearance of a halo that surrounds the edge, giving your images an unpleasant and obviously manipulated look.

jargon busting: Sharpening halos

Printing

Having captured a great shot, and spent time on cleaning and perfecting your image, it's not unreasonable to expect a perfect likeness when you finally print. Unfortunately, it's not quite this simple. Despite the high quality of even budget photo printers, achieving a good colour match can be tricky. Making high-quality prints is far more complex than you might imagine. There are whole books dedicated to the art of printing, so I'm only able to scratch the surface here. However, colour management is vital.

Digital cameras, monitors and printers all see colour differently. In other words, the file produced by your camera will probably differ slightly from the image displayed on the computer and the final print. To limit the difference, it's best to stick to one ICC profile, from digital camera through the post-processing phase to your printer. If you're taking pictures purely for the purpose of printing, it's easiest to choose sRGB as your profile, as this is the standard default for most printers. This will not guarantee a perfect colour match, but results should still be quite accurate.

For consistent results, it helps to calibrate your system, starting with your monitor. This is best done using a hardware tool, like the ColourVision Spyder, which measures the monitor's performance using various standardized colours. Once completed, an ICC profile is created, and this will translate the characteristics of your monitor to other applications. If you don't wish to go to this expense, you can try making test prints – using the same paper type – and then, depending on the results, make any alterations to brightness or colour. Calibrating your system is costly and time-consuming, which is fine if you're selling your work; but for most photographers trial and error gives good enough results.

▶ (stylusr320.tif © Epson)
The Epson Stylus R320, one of many reasonably priced multi-cartridge photo printers available today.

Paper

Although specific photo papers and inks seem pricey, they're actually comparatively cheap. Naturally, the paper you decide to use will greatly affect print quality, but with so many different types on the market it can prove confusing, so here are some of the key qualities to look for.

Texture There are many types available, but the majority can be placed within two categories, either a matte or glossy finish. Shiny papers are generally resin-coated and typically range from high-gloss, through semi-gloss to a standard gloss. Matte papers come in a variety of surfaces ranging from smooth to rough, including art and watercolour-style papers. The trick is matching the paper to a suitable shot. In truth, a standard gloss finish of some variety will be best suited in most situations, but it really is worth trying different types yourself. I prefer using paper with a glossy finish and normally opt for semi-gloss.

Weight Paper is measured in grams per square metre (gsm or g/m2). The weight of the paper you employ will greatly affect the feel of the final printed image. Ordinary printer/photocopier paper is normally 80g/m2, but photo paper is much heavier: not only to give it

ICC (International Colour Convention) profiles are universal colour standards that apply to your image. An image with a certain ICC profile, should appear identical wherever it's viewed – presuming the monitor is calibrated. For this reason, ICC profiles are especially important when sharing images between devices. An ICC profile is the only way to guarantee the recipient will see the same colours as you do. There are many different ICC profiles, but the two most commonly used and accepted are Adobe 1998 and sRGB. Adobe 1998 has a larger colour range, making it the preferred colour profile for most publications and magazines, while sRGB is more appropriate for monitor-based applications such as the Internet.

jargon busting: ICC profiles

the feel of a genuine photo, but also to absorb the quantity of ink and prevent bleeding (when colours merge). Heavy paper is also more resistant to rippling and damage. To produce quality prints of A4 and above, I recommend you use a photo paper of 250g/m2 or greater.

Archival quality While every photograph will ultimately fade, some companies claim their papers will resist fading for 100 years or more. Special coatings and absorption properties are helping to ensure a greater level of damage resistance from air, light and moisture. My advice is always to match high-quality photo paper with the latest inks. If you do this, and store the prints away from direct sunlight, there's no reason why your pictures shouldn't still look fresh in at least three or four decades time.

Ink

Printer cartridges might seem expensive, but it's best to avoid the temptation to buy cheap cartridges. For the best results, always employ ink recommended and produced by the manufacturer of your printer. The inks used in inkjet printers are either dye- or pigment-based, depending on the make and model.

Dye-based inks Dye-based inks are chemicals that are dissolved. They are less expensive than pigment inks, but they're also less light-resistant and chemically stable. Early dye-based inkjet prints faded rapidly, but newer dye-based inks are greatly improved and can reputedly last up to 20 years or more if displayed beneath glass. Dyes can interact chemically with photo-paper coatings, however, so check first that the paper you've selected is compatible with the inks your printer uses.

Pigment-based inks In contrast to dyes, pigments are tiny particles that come suspended in the solvent, so they're not dissolved. Although they're more expensive, pigment inks are far more lightfast and chemically stable. Manufacturers estimate longevity of between 80 to 200 years. Although early pigment inks had a tendency to clog printer nozzles, they're now much improved. Pure pigment inks can struggle to achieve a high Dmax (maximum density), so dyes are often added to pigmented ink-sets, as black dyes are more stable than coloured ones.

Naming files

While your camera will automatically name each shot, it is best to re-save them using logical names that are expandable. It's best to limit filenames to eight characters, as the common format and default for writing images to CD (called ISO 9660) only recognizes up to eight characters (plus a three character extension such as .tif). This ensures that the shots will be grouped together, and that you can add more in the future. Once the naming is complete you can store them in an appropriately named folder.

◀ (mfrit01.tif)
Name your files using simple, logical filenames.

▼ (mfrit02.tif)
Although it's best to keep the filename short and simple, it's a good idea to add more information using the IPTC fields in Photoshop. Click (File>File Info) to open the File Info box.

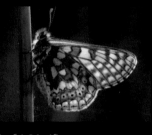
(mfrit01.tif)

(mfrit02.tif)

Cataloguing

One of the biggest problems is remembering where your images are located. This might not be too bad while you have just a few hundred images, but your catalogue will soon grow. Operating systems such as Windows XP or Mac OS X can be used to manage modest collections, as they automatically display image thumbnails. I suggest you create a new folder (File>New>Folder in Windows) or (File>New Folder in OS X) for each category. For instance, plants, insects, textures, colour and so on. Now drag and drop the relevant shots within the new folder. As you add more pictures, you may wish to create subcategories: folders within folders. A cataloguing system like this might be basic, but will make your shots easier to locate.

I doubt it will be long before your picture collection outgrows such a simple system, and when this happens the answer is to invest in image-cataloguing software. There are several programs on the market, but one of the most popular among pros is Extensis Portfolio. One of the biggest benefits of software like this is that it is location-independent; so it will always know where the original file is kept, even if you're relying on CDs or DVDs for storage. Each picture is given a sequential reference number before being dragged and dropped into the new portfolio. A description and keywords should be added to allow you to search for the picture you require later.

Storing and archiving files Shooting digitally is convenient, and, while it doesn't take up the same physical space as thousands of negatives or slides, a digital image is very easy to lose or destroy, so storage is still important. However, there are a few things you can do to ensure that you never lose valuable files.

Firstly, do not keep the only copy of your digital images on your hard drive, as not only will it slow down your computer, but hard drives can and do fail. When I was still new to digital photography, I lost a number of shots after a lightning strike destroyed my PC due to a massive power surge. In my view, the best form of back-up is an external hard drive, see page 26. They're affordable, have a large capacity, and it's simple and quick to duplicate pictures from your computer. An external hard drive makes it easy to back up images immediately after they've been downloaded onto your computer, and again after you've processed and resaved the images. Personally, I store processed tiffs and the original RAW files on different external

devices, to give me added security. I also store a separate copy off-site, so if there was a fire or a break-in I wouldn't lose any of my shots. Obviously, being a professional, I can justify buying several external hard drives. However, for the majority of digital photographers, one large-capacity model should do the job.

Alternatively – or in addition – you could store your images on disk. I suggest you use DVDs; they're pricier, but have a far greater capacity than an ordinary CD. However, DVDs can be less stable, and ██ ███uld burn them at a maximum of 2x speed and always verify ██em. Obviously, disks need to numbered, labelled, and then organized into a system which will make images easy to locate again later. Disks are ideal for smaller collections, but in my view are not long-term solutions for archiving. I do use DVDs as a supplement to an external device, but they are easily damaged, and frequent use and age are known to cause a degree of deterioration. It's also easy to build up a huge stack of disks, and it can become increasingly difficult to find the one you're after. Also, when using large-capacity DVDs as your only form of back-up, it can be tempting to wait until you have enough images to fill a disk. Most DVDs can store up to 4.7GB of data, so it might be weeks or even months before you can do this – defeating the object of using them as a regular method of backing up

Many people only get into the habit of regularly backing up their images once they've already lost valuable shots. Don't become one of them. You should ensure your images are archived, either on disk, exte█al hard drive or both. Do this on a weekly basis, at the very eas█ Remember: you cannot have too many copies of each image. This might sound a little excessive, but, having invested so much time and skill in capturing a great photo, do you really want to take any chances?

CD-R / 1x-52x
700MB, 80 min

CD-R

GLOSSARY

Aberration An imperfection in the image, caused by the optics of a lens. Although all lenses suffer from aberrations, many are corrected through the lens's construction.

Adobe Photoshop The most widely used image-manipulation program.

Ambient light Light available from existing sources, as opposed to artificial light supplied by the photographer.

Aperture The hole or opening formed by the opening in a camera lens through which light passes to expose the image-sensor. The relative size of the aperture is denoted by f-numbers.

Autofocus (AF) The camera's system of automatically focusing the image.

Buffer The in-camera memory of a digital camera that stores images before they are written to the memory card.

Burst size The maximum number of frames that a digital camera can shoot before its buffer becomes full.

Camera shake Movement of camera caused by an unsteady hold or support. This can lead, particularly at slower shutter speeds, to a blurred image.

CCD (charge-coupled device) A microchip made up of light-sensitive cells that is commonly used in digital cameras for recording images.

CMOS (complementary metal oxide semiconductor) A microchip made up of light-sensitive cells and used in digital cameras for recording images.

CMYK Cyan-magenta-yellow-key (black).

Colour temperature Description of the colour of a light source by comparing it with the colour of light emitted by a theoretical perfect radiator at a particular temperature expressed in Kelvin (K). Note that 'cool' colours such as blue have high colour temperatures, and vice versa.

Compression The way in which digital files, particularly jpegs, are reduced in size.

Cropped sensor A digital sensor that is smaller than a 35mm frame.

Depth of field The amount of the image that is acceptably sharp. Depth of field extends one third in front of and two thirds behind the point of focus.

Depth-of-field preview Some DSLR cameras offer the chance to see the available depth of field by stopping down the aperture to its shot setting while the reflex mirror remains in place.

Diaphragm The mechanism for adjusting the aperture of a lens.

Diffuse lighting Lighting that is low or moderate in contrast, such as that which occurs on an overcast day.

Diffuser An object used to diffuse or soften light. Often a diffuser for a flash unit is used to 'soften' shadows.

dpi (dots per inch) A measure of the resolution of a printer.

DSLR (digital single lens reflex) A type of camera that allows you to see through the camera's lens as you look through the viewfinder. Also compatible with interchangeable lenses.

Effective megapixels The actual number of pixels that make up the viewable image captured by a digital camera.

Extension tube A ring fitted between the camera and the lens to increase the distance between lens and image-sensor. This allows a larger reproduction ratio than usual and is useful for macro photography.

File size The number of bytes, of memory or disk space, required to store a digital file.

Fill-in flash Flash combined with daylight in an exposure. Used with naturally backlit or harshly side-lit subjects to add extra light to the shaded areas of a well-lit scene.

Filter A piece of coloured glass, or other transparent material, used to affect the colour or density of the scene.

Focal length The distance, usually given in millimetres, from the optical centre point of a lens element to its focal point.

f-number A fraction that indicates the actual diameter of the aperture: the 'f' represents the lens's focal length.

Gigabyte (GB) A unit of computer memory equal to 1,024 megabytes.

Highlights The brightest parts of an image.

Histogram A two-dimensional graph showing the brightness range of an image.

Hotshoe An accessory shoe with electrical contacts that is normally mounted over the optical axis, allowing synchronization between the camera and a flash unit.

Interpolation The estimation of data, used to create new pixels by estimating their data from surrounding ones.

ISO (International Standards Organization) The international standard for representing film sensitivity.

Jpeg A standard compressed image file developed by the Joint Photographic Experts Group.

Kelvin (K) A scale used to measure colour temperature.

LCD (liquid crystal display) A screen on a camera that provides information in the form of alphanumeric characters and symbols. Often used to display exposure settings, frame count, ISO rating, etc.

Lens One or more pieces of optical glass, or similar material, designed to collect and focus rays of light to form a sharp image.

Macro lens A lens that allows close focusing and large image magnification. True macro lenses produce a 1:1 reproduction ratio or greater.

Megabyte (MB) A unit of computer memory. One megabyte is equivalent to 1024 kilobytes, or 1,048,576 bytes.

Megapixel One million pixels.

Memory card Removable storage device for digital cameras.

Metering Using a camera or lightmeter to determine the amount of light coming from a scene and calculate the required exposure.

Noise The digital equivalent of grain, caused by stray electrical signals.

Overexposure A condition in which too much light reaches the sensor. Detail is lost in the highlights.

Pixels Abbreviation of picture elements. The individual units which make up an image in digital form.

Polarized light Light waves vibrating in one plane only as opposed to the multi-directional vibrations of normal rays. This occurs when light reflects off some surfaces.

Post-camera processing The use of software to make adjustments to a digital file on a computer: saturation, white balance etc.

ppi Pixels per inch: a measure of the resolution of a digital image.

Raw A digital file format used by many digital cameras, with shooting parameters attached, not applied.

Reflector A surface from which light is reflected for use as an additional light source.

Reproduction ratio The ratio of the size of the real-life subject to its image in the focal plane.

RGB Red-green-blue.

Shooting parameters User-defined actions, either in camera or during post-processing on a computer, such as white balance, saturation, contrast and sharpening.

Shutter A curtain, plate, diaphragm, or some other movable cover in a camera that controls the amount of time during which light reaches the image-sensor.

Shutter speed The length of time that the shutter is open. Measured in seconds or fractions of a second.

Spot metering A metering mode that takes a light reading from a very small portion of the scene, often as little as 1%.

Through-the-lens (TTL) metering A meter built into the camera that determines exposure for the scene by reading light that passes through the lens during picture taking.

Tiff Tagged image file format: an uncompressed digital image file.

Underexposure A condition in which too little light reaches the sensor. There is too much detail lost in the areas of shadow in the exposure.

White balance A function on a digital camera that allows the correct colour balance to be recorded for any given lighting situation.

USEFUL WEBSITES

Calibration
ColorVision: www.colorvision.com
Pantone: www.pantone.com

Image storage
Lacie: www.lacie.com
Lexar: www.lexar.com
Maxtor: www.maxtor.com
Smartdisk: www.smartdisk.com

Photographer
Ross Hoddinott: www.rosshoddinott.co.uk

Photographic equipment
Canon: www.canon.com
Epson: www.epson.com
Gitzo: www.gitzo.com
Lastolite: www.lastolite.com
Lowepro: www.lowepro.com
Manfrotto: www.manfrotto.com
Metz: www.metz.de/en
Nikon: www.nikon.com
Novoflex: www.novoflex.com
Olympus: www.olympus.com

Paterson: www.patersonphotographic.com
Pentax: www.pentaximaging.com
Sandisk: www.sandisk.com
Sigma: www.sigma-photo.com
Sto-fen: www.stofen.com
Tamron: www.tamron.com
Wimberley: www.tripodhead.com

Publisher
PIP: www.pipress.com

Sensor type
FourThirds: www.four-thirds.org
Foveon: www.foveon.com

Software
Adobe: www.adobe.com
Extensis: www.extensis.com
ImageRecall: www.imagerecall.com
Lizardtech: www.lizardtech.com

Supplier
Mifsuds: www.mifsuds.co.uk

INDEX

Photographers' Institute Press, an imprint of The Guild of Master Craftsman Publications Ltd,
166 High Street, Lewes, East Sussex BN7 1XU
Tel: +44 (0) 1273 488005 Fax: +44 (0) 1273 402866
www.pipress.com